IMAGES
of America

CHICAGO'S PARKS

A PHOTOGRAPHIC HISTORY

10/03

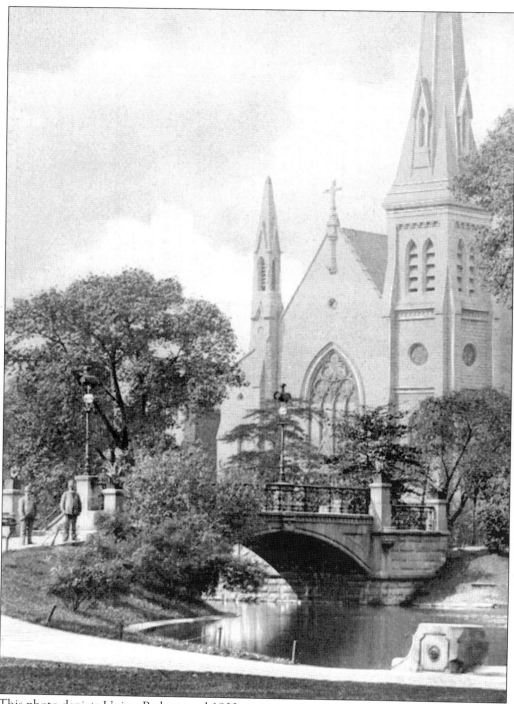

This photo depicts Union Park around 1900.

IMAGES
of America

CHICAGO'S PARKS

A PHOTOGRAPHIC HISTORY

John Graf

ARCADIA

First Printed 2000.
Reprinted 2001, 2002.

Published by Arcadia Publishing,
an imprint of Tempus Publishing, Inc.
3047 N. Lincoln Ave., Suite 410
Chicago, IL 60657

Printed in Great Britain.

Library of Congress Catalog Card Number: 00-102574

For all general information contact Arcadia Publishing at:
Telephone 773-549-7002
Fax 773-549-7190
E-Mail sales@arcadiapublishing.com

For customer service and orders:
Toll-Free 1-888-313-2665

Visit us on the internet at http://www.arcadiapublishing.com.

CONTENTS

ACKNOWLEDGMENTS

Acknowledgment and appreciation is due to countless interested citizens, scholars, and institutions who provided me with various materials, photographs, and encouragement for this book over the years. I would especially like to thank the staff of the Harold Washington Library Department of Special Collections, the Municipal Reference Library staff, Father George Lane at Loyola University Press, the staff of the Chicago Historical Society, Kenan Heise at Chicago Historical Bookworks, the staff of the Newberry Library, Glenn E. Humphreys—the Special Collections Librarian at the Sulzer Regional Library, the staff at the Burnham Library of Architecture, Mary Jo Doyle at the Rogers Park Historical Society, the staff at the City of Chicago Commission on Chicago Landmarks, Dr. Mercedes Graf for the large postcard collection and assistance with editing, the staff of the Chicago Park District, Patricia Kelly Reichart for the information and photographs of Kelly Park, the University of Chicago Library staff, Christine Hennessey at the National Museum of American Art for the information on Chicago sculpture, the staff at Friends of the Park, Sheila Robak at Rosehill Cemetery for the photographs and maps, the staff at the Library of Congress, the Hyde Park Historical Society, Andersonville Chamber of Commerce, the Chicago Catholic, the staff of the *Chicago Tribune*, the staff of the *Chicago Sun-Times*, the office of Mayor Richard M. Daley, Steve Skoropad at North Shore Photography for his tremendous assistance, Patrick Catel and the staff at Arcadia Publishing for making this project a reality, and last but not least, a special thanks to my wife Marina for her incredible patience and understanding.

FOREWORD

By Kenan Heise

By celebrating Chicago's 550 parks—large and small—in book form, John Graf has done a wonderful service for the city, its residents, and the park system. His effort, rich in detail, will bring many individuals to exclaim, "I didn't know that!" They will find themselves discussing the origin of a name or a piece of history associated with a park located a block or two (sometimes less) away from where they have lived since birth.

The book will help reintroduce all of us to those publicly-owned pieces of land that exist solely for the purpose of our enjoyment. It will help us to regain the perspective a child has in yelling "Oh boy!" when he or she, upon discovering a park, runs to embrace it. The time is indeed propitious. Chicago's parks have gone through one of their least appreciated eras. Beset by problems arising from patronage staffing, a changing city, and budgets that have not allowed for adequate repair and maintenance, they have seen their reputations plummet. People, especially those who have moved away from the city, have perceived them as gang-owned and places in which to invite muggings. This view has especially weighed heavily upon the city's small parks. Their appearance and maintenance have been argued for such a conclusion.

Other Chicagoans—especially those who have stayed or actually moved back to the city—have retained their belief in local parks as places in which to recreate and renew one's body and spirit, take small children to play, and let older children participate in sports and other community activities.

A spirited interest in the city's parks has grown by leaps and somersaults in recent years, with new people finding renewed purposes for them. Increasingly, they are not being viewed or treated simply as empty lots covered with grass and trees. Rather, they see them as communal places for life at all levels from trees and grass to animals and humans—a view of Chicago's Lincoln Park that artist/story-teller Scott Holingue espoused in his book, *Tales of an Urban Wilderness.*

Within the last few decades, the city's parks have become safer. The ubiquitous cement under slides and swings have been replaced with wood chips and dirt. Neighborhoods, in addition, have united to take back their parks, tending them, reporting crime and performing various forms of "park watch" activities. The city has begun to appreciate the beneficial effects of foliage and trees, rather than continuing to cut them down, and is now planting them *en masse.*

Perhaps what the author, through his pictures and words, has best done in this book is give back individuality to the parks of Chicago. He has helped local residents, and all of us, to better appreciate the names, history, and details of that which we have too long taken for granted. This unprecedented book is both a refreshing sign that Chicago is, more than ever, finding it a good time to stop and smell the flowers and to appreciate all the parks have to offer.

INTRODUCTION

No other city in the world has a park system as great as Chicago's, which includes over 550 parks totaling more than 7,000 acres. The parks range in size from small tracts of land less than .1 acres, to giant parks measuring over 1,200 acres. Each park has its own story as well as its own unique characteristics and history. Yet the great majority of us are not aware of the wealth, variety, and sheer number of parks that exist, to say nothing of the ideas they project, the history they commemorate, or the manner in which they were named.

Chicago's first park, Dearborn Park, was established in 1839. The 1.08 acre parcel of land had formerly been a part of the old Fort Dearborn military post named in honor of General Henry Dearborn, Secretary of War under Thomas Jefferson. Few people guessed that this small tract would be the start of one of the greatest park systems in the world. Between 1839 and the mid-1860s, many other parks were created, including Washington Square, Union Park, and Ellis Park. However, all of these parks were small—less then 5 acres in size, with Union Park being the exception at 17 acres. In fact, many of the parks were just small parcels of land or triangles at street intersections that were turned into parks. Others were oddly shaped lots that were donated to the city by developers hoping to enhance the value of new subdivisions. Not until 1864, when the city council passed an ordinance creating "Lake Park" (now Lincoln Park) on the North Side of Chicago, were steps taken to create a truly large and significant park.

A formal plan for the creation of a park system was developed in 1869, and Chicago soon had some of the greatest parks to be found anywhere in the country or the world. These "great" parks included Garfield, Douglas, and Humboldt Parks on the West Side; Lincoln Park on the North Side; and Washington and Jackson Parks on the South Side. Parks on the outskirts of town that were linked by a connecting boulevard system formed a ring around the city that was referred to as the "Emerald Necklace" or the "Emerald Crown." In Chicago's early days, both "great" and large parks tended to be named after presidents such as Lincoln, Jackson, Washington, Grant, and Garfield. This was because the majority of the park commissioners were natives of this country, and many were businessmen and politicians who liked to identify themselves with presidents.

By 1890, the population of Chicago surpassed one million, and by 1900 the population reached nearly 1.7 million; such growth indicated that a different kind of park was now needed. The city had changed drastically, but its park system had not. The "great" park model that had emerged had been the dominant park type for the last 30 years, but the working-class, the poor, and the immigrants felt that such parks were not enough. They needed playgrounds and parks in their neighborhoods to meet their families' recreational needs. In 1899, the city council formed the Special Park Commission. In May of 1900, Mayor Carter Harrison appointed the commission to study and report on the conditions of working-class areas. This group, along with social reformers, responded by establishing a program to develop "breathing spaces" in these working-class neighborhoods. One of their objectives was to provide parks for people that were no more than a half a mile away.

The Special Park Commission, in conjunction with the South, West, and Lincoln Park Commissions, began buying land to develop parks in the inner city and recruited the leading architects in the country to design the new neighborhood parks. The result was a model park

leading the way for other parks in metropolitan areas around the country. Neighborhood parks were so successful by 1916, that there were over 50 of them in the city's immigrant and working-class areas. After seeing the benefits of these parks, middle-class residents of Chicago began building them in their own communities.

Several parks during this period were named for explorers such as Columbus, Marquette, and Amundsen. Some of the districts preferred Native American names like Blackhawk, Chippewa, and Indian Boundary; other districts used the names of soldiers such as Bell, Kosciuszko, Revere, and Sheridan; and a few used musicians' names such as Chopin, Dvorak, and Mozart. In some districts, the practice was simply to use adjacent street names. That is how Ada, California, Kilbourn, and various other parks came to be named. In other cases, the name of the alderman submitting the order to establish the park was used, like Christ Jensen and John Wilson.

In 1934, the South, West, and Lincoln Park Commissions, along with the other 19 small park districts, merged and became known as the Chicago Park District. In 1935, President Franklin Roosevelt created the Works Progress Administration (WPA), which focused on improving the parks. In 1945, a ten-year park development plan was introduced, followed in 1949 by the school-park plan. Under the last plan, the Chicago Park District, in conjunction with the Chicago Board of Education, launched a program which combined the use of school and park facilities. In 1959, the Functional Consolidation Act was introduced so that there could be an exchange of services between the city and the park district. In 1969, the Chicago Park District introduced the Neighborhood Improvement and Beautification (NIB) program that allowed vacant sites to be converted to playlots. In May of 1973, 25 of the numbered sites were given names. All 25 parcels were named after trees, plants, flowers, shrubs, or bushes— Birch, Butternut, Catalpa, and Walnut are examples. In 1974 and 1975 more parks were named, usually reflecting horticultural themes.

Succeeding mayors like Washington and Daley continued park improvements. Under Daley, the Park District implemented a plan—Neighborhoods First: A Program Quality Initiative. In an effort to be more sensitive to the needs of its users, several parks were renamed after local citizens at the request of community groups. Finally, the park amended Chapter VII. E of the Park District Code, which governs the naming and renaming of parks. The code essentially states that whenever possible , all future park names will reflect historical or physical features of the surrounding neighborhoods.

Today there are eight different kinds of parks as defined by the Chicago Park District. There are "magnet parks" (large parks in excess of 50 acres), "citywide parks" (also large parks in excess of 50 acres), and "regional parks" (between 15 to 50 acres serving those living within .75 miles). There are also "community parks" (generally between five and 15 acres, serving people within .5 miles), "neighborhood parks" (between .5 and five acres), and "mini-parks" (less than .5 acres in size). The latter two park types contain the majority of playlots. "Passive/natural parks" are landscaped parks without indoor or outdoor facilities for active recreation. Finally, there are "unimproved parks," which are generally vacant tracts of land that have been acquired for future park development.

When Chicago was founded in 1837, the city's Fathers adopted the motto "urbs in horto," or "the city set in a garden." What great vision our forefathers had! Despite all the politics and all the changes that have taken place over the past 160 years since Dearborn Park was created, Chicago is still a city set in a garden.

One

PARKS OF THE
WEST SIDE

Several of the oldest parks in the city can be found on the West Side. Some of the earliest that were established include Jefferson (now Skinner) in 1848, Union in 1854, and Vernon (now Arrigo) in 1857. The three "great" parks (Douglas, Garfield, and Humboldt) were founded in 1869 when the state legislature created the Board of West Chicago Park Commissioners. Because the commissioners wanted to establish some of the finest parks in the city, they hired prominent Chicago architect William Le Baron Jenney (1832–1907) to design these "great" parks. When these parks were completed, they were, in fact, some of the most beautiful parks in the country.

After 1869, many other parks were created on the West Side. Some of the parks pictured here include: Campbell, Columbus, Dvorak, Eckhart, Franklin, Harrison, Holstein, Merrick (now Levin), Pulaski, and Sheridan. During the period from 1912 to 1916, large increases were made in the recreational facilities of this West Side system. Playgrounds, swimming pools, and fieldhouses were built at several parks. In addition, all three of the "great" West Side parks also had Artesian wells and conservatories.

The West Side parks contain many notable monuments, which are represented in this chapter. For example, Union Park has the Carter Harrison statue, Humboldt Park houses the statue of its namesake, Garfield Park contains statues of Lincoln and Robert Burns, and there is a statue of Columbus in Arrigo Park. Many of the early park scenes shown here also reflect the picturesque landscapes that were once commonplace in West Side parks.

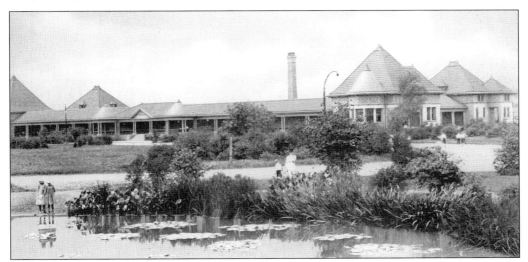

Douglas Park, located at 1401 South Sacramento Avenue, is named after Stephen A. Douglas (1813–1861). "The Little Giant," was a U.S. Congressman and Senator. He ran for President in 1860, but was defeated by Abraham Lincoln. The park is 174 acres in size and was established in 1869. Originally known as South Park, it was renamed in honor of Douglas on November 4, 1869. The park was designed in 1871 by William Le Baron Jenney (1832–1907).

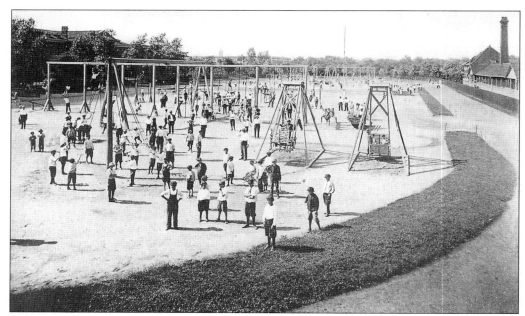

This is a 1916 photograph of the outdoor gymnasium in Douglas Park. This scene demonstrates the success of placing parks in crowded districts, where neighborhood residents had access to the facilities for recreation. Parks became meeting places for athletic clubs and other organizations. In this photo, a group of men and boys are gathered to participate in gymnastic activities.

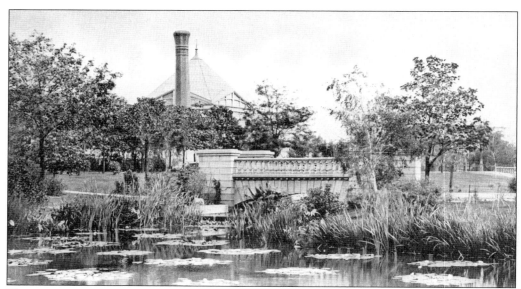

This is a view of Douglas Park prior to 1905. This is a scene of the stone bridge with the greenhouse in the background. This bridge is one of the few surviving elements of architect William Le Baron Jenney's original design for the park. In the early years, neighborhood citizens gathered here for various occasions and holidays.

This is another view in Douglas Park around 1900. Tranquil scenes such as this are not as common in the park today. In fact, the appearance of the park has changed greatly over the years, but it still retains some of its early elements including the lagoon and a wide variety of trees. The park is very popular with residents of the North Lawndale area in which it is located.

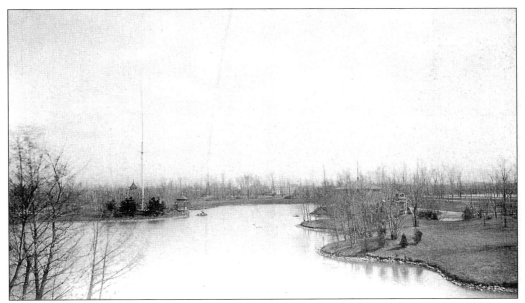

This is an 1882 view of Douglas Park, looking south from the boat landing. Designer William Le Baron Jenney had started from scratch just eleven years earlier when he began to design the park. The park had to be raised to grade level by filling it in with manure and sand. Today it houses football fields, combination football and soccer fields, and an oval track.

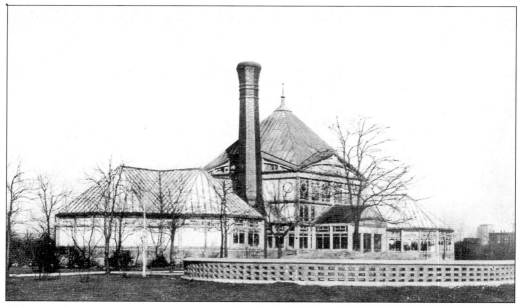

This greenhouse is no longer standing in Douglas Park. Originally one of the three great West Side parks, Douglas gradually lost its early splendor. The once-beautiful greenhouse that attracted citizens from all parts of the city was torn down in 1905, because it had fallen into a state of disrepair.

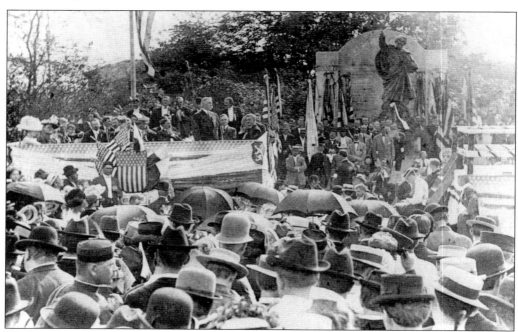

This is a photograph of Douglas Park in 1910. The occasion is the unveiling of a statue of Czech patriot Karel Havlicek (1820–1856). The unveiling was attended by a crowd of nearly 20,000 people. The statue is the work of sculptor Joseph Strachousky. It was removed from the park in 1981 and now stands near the Adler Planetarium.

14

Altgeld Park, located at 515 South Washtenaw Avenue, is named after John Peter Altgeld (1847–1902), who was a lawyer, judge, and Governor of Illinois from 1892–1896. He is most famous for granting pardons to the Haymarket Bombing prisoners in 1893. During his term as governor, he helped to enlarge Chicago's Public Park System. The history of the park dates back to 1875 when brothers Frank and James Campbell donated 1 acre of land to the city to be used as a park. This is a photograph of the park's Classical Revival-style fieldhouse, which was built around 1915.

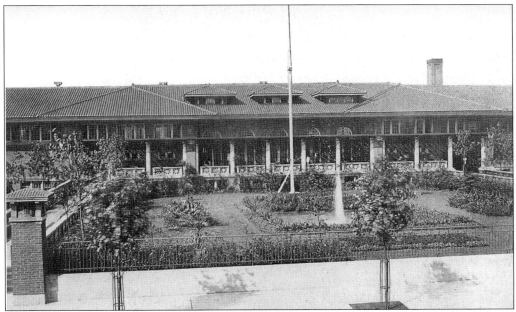

This is a photograph of the fieldhouse in Stanford Park taken in 1916. The fieldhouse boasted a terra cotta roof, a series of open air terraces, and a small formal garden. Fieldhouses were an important aspect of early park design, as they allowed people to utilize the facilities for a variety of recreational and leisure pursuits. Nearly 3 acres in size, this small park was located at 14th and Union. The fieldhouse was torn down many years ago, and the park no longer exists.

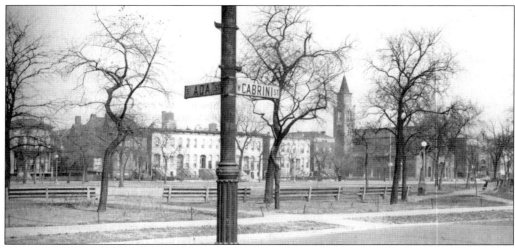

Arrigo Park, located at 801 South Loomis Street, is named after former Illinois State Senator Victor Arrigo (1908–1973). Some of the old-timers in the area refer to the park as "Peanut Park," because the walkway around the park is shaped like a peanut. The land for the park was donated to the city in 1857. Formerly known as Vernon Park, it is one of the oldest existing parks in the city of Chicago. Many of the homes on Lexington Avenue that were built in the 1870s face the park and are still standing.

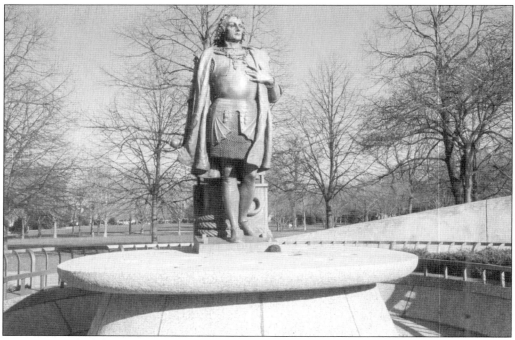

Sir Moses Ezekiel (1844–1917), a highly respected sculptor, designed the centerpiece of Arrigo Park—a 10-ton statue of Christopher Columbus that stands in the middle of a granite fountain. The statue was originally exhibited at the 1893 World's Columbian Exposition. The statue later stood over the entrance to the Columbus Memorial Building at 31 North State Street. The statue was relocated to the park in 1966, and unveiled in a dedication ceremony on October 12, 1966.

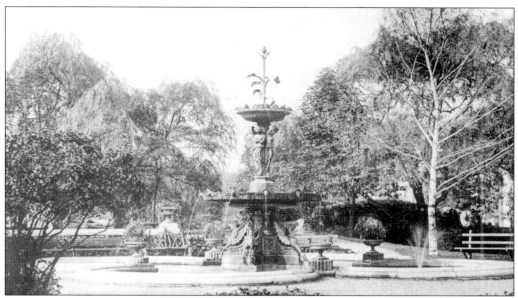

Jefferson Park, located at 1331 West Monroe Street, is the second oldest existing park in the city of Chicago, having been established in 1848. Once a charming park with winding paths, grottos, fountains, and a lake, it is now a mere shadow of its former self. Even the name of the park has been changed. It is known today as Skinner Park, in honor of prominent Chicagoan Mark Skinner (1813–1887). The name was changed in the mid-1950s, because the park is located next to Skinner School.

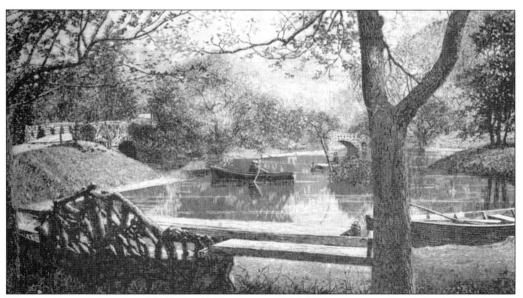

This is a very early view of Jefferson Park prior to 1886. This is a typical summer boating scene in the park during this period. Even though the park has changed drastically and the lake has been filled in, the park is still quite popular with local residents who stroll, jog, and bike there. People who work in the area also frequent the park. It is located across the street from the Chicago Police Training Center, and close to several area hospitals.

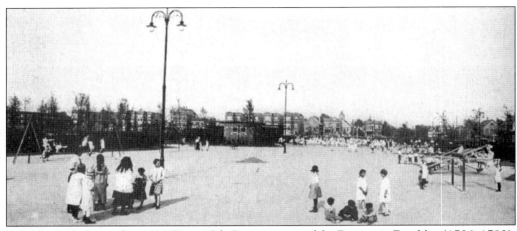

Franklin Park, located at 4320 West 15th Street, is named for Benjamin Franklin (1706–1790), one of the greatest statesmen of the American Revolution, and also a signer of the Declaration of Independence. An extremely versatile man, Franklin is remembered for his experiments with electricity, his invention of the lightning rod and the Franklin stove, his creation of bifocal eyeglasses, and his publication, *Poor Richard's Almanac*. This is a 1916 view of the children's playground in the park.

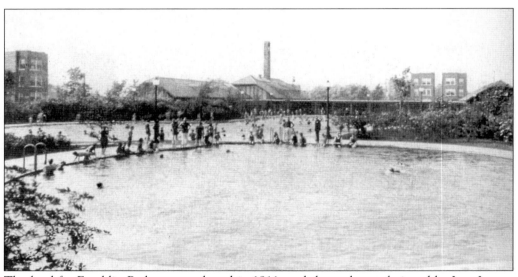

The land for Franklin Park was purchased in 1911, and the park was designed by Jens Jensen between 1914 and 1916 as part of the West Park Commission's Neighborhood Park Plan. Originally known as Small Park #4, it was renamed in honor of Benjamin Franklin on January 22, 1913. This is a picture of the pool that was placed in the park during 1916, at a cost of nearly $60,000.

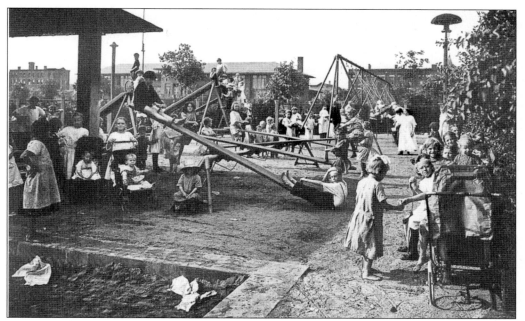

Dvorak Park, at 1119 West Cullerton Street, is located on the Lower West Side. It is named after the Czech composer, Antonin Dvorak (1841–1904). The land for the park was acquired on March 15, 1907. This is a 1916 photograph of the playground, which shows children having fun on the swings and seesaws in the park.

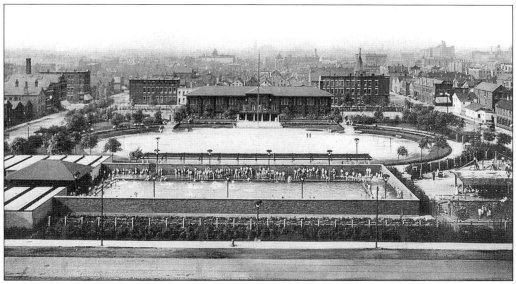

Dvorak Park was designed in 1908 by William Carbys Zimmerman and Richard Ernest Schmidt of the architectural firm of Schmidt, Garden & Martin. Zimmerman also designed the park's Prairie-style fieldhouse. The landscape architect for the park was Jens Jensen. Originally known as Small Park #3, it was renamed in honor of Dvorak on January 22, 1913. This is a 1915 aerial view of the park.

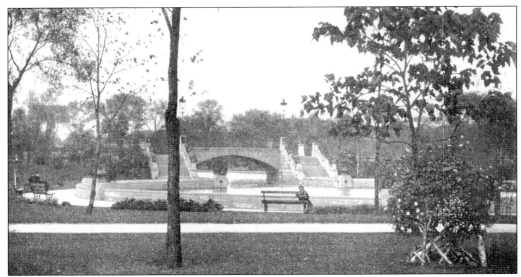

Union Park, located at 1501 West Randolph Street, was named in honor of the Union cause during the Civil War. The land for the park was acquired in 1854, and soon became one of the most beautiful sites in all of Chicago during the 1860s and 1870s. It also became the focal point of the swank neighborhood around the park. The park contained well-manicured grounds, a lagoon, beautiful iron bridges, fountains, gazebos, a conservatory, a small city zoo, and a band shell used for weekly concerts during the summer months. It is one of the oldest existing parks in the city.

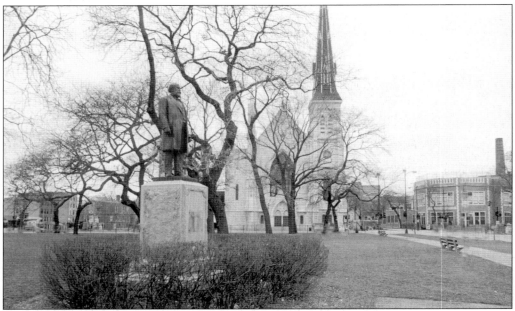

This is a photograph of the statue of Chicago Mayor Carter Henry Harrison, which stands in Union Park and was designed by sculptor Frederick Cleaver Hibbard. Harrison was a lifelong resident of the area and spent much of his free time in this park. The Union Park Congregational Church on Ashland Avenue near Madison Street, which was completed in 1871 and seen here in the background, still faces the park today.

This is a photograph of the Haymarket Monument in Union Park taken during the early 1900s. The statue, which is the work of sculptor John Gelert (1852–1923), originally stood in Haymarket Square on Randolph Street. It was created in memory of the policemen who were killed in the Haymarket Riot on May 4, 1886. The statue no longer stands in the park, and is now located in the courtyard of the Chicago Police Training Center.

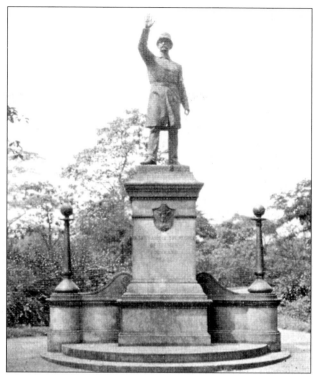

This is believed to be an 1850s scene in Union Park on the West Side. It was often referred to as "a little gem park," and abounded with rustic bridges as pictured here. Note the bridge spanning the lagoon, which provided a picturesque walk for the early residents who strolled here from their nearby fashionable residences.

Eckhart Park, located at 1330 West Chicago Avenue, is named after Bernard Albert Eckhart (1852–1931). He came to Chicago in 1870 and founded the Eckhart & Swan Milling Company. He was also a director of several Chicago banks, an Illinois State Senator, Director of the Chicago Board of Trade, and President of the West Side Park Commission in 1905. This is a 1915 photograph of one of the park's swimming pools.

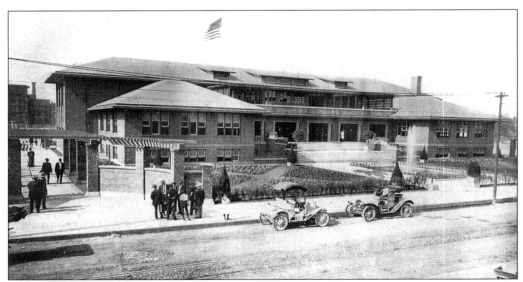

The land for Eckhart Park was purchased in 1907. When it was acquired, it was cluttered with dilapidated tenements that had to be razed to make way for the park, which was designed in 1908 by William Carbys Zimmerman and Jens Jensen. When the park was officially opened on August 1, 1908, it was known as Small Park #1. In 1910 over 740,000 people used the park's facilities. In 1913, the park was renamed in honor of Eckhart. This is a 1915 view of the park's Prairie-style fieldhouse designed by Zimmerman.

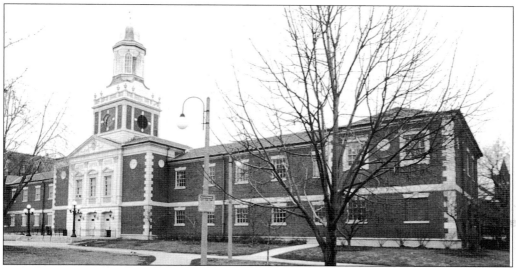

Austin Town Hall Park, at 5610 West Lake Street, is named after Henry W. Austin (1828–1899), who founded the Austin Park neighborhood. In 1865, he donated the land for the park to the Town of Cicero. The park was originally known as Holden Park and housed the Cicero Town Hall. In 1899 the area was annexed to Chicago, and the city took control of the park. On March 28, 1929, the name of the park was changed to honor Austin. In 1929, a replica of Independence Hall in Philadelphia, designed by the architectural firm of Michaelsen & Rognstad, was erected in the park.

This is an early view of the entrance to Merrick Park, located at 5458 West Kinzie Parkway. Charles C. Merrick owned the subdivision in which the park is located, and he donated the land for the park to the city. The park is known today as Levin Park, in honor of John H. Levin (1887–1971). Levin was a park commissioner from 1946 until 1969, and he owned Little Jack's restaurant at Kedzie and Madison Avenues for over 60 years.

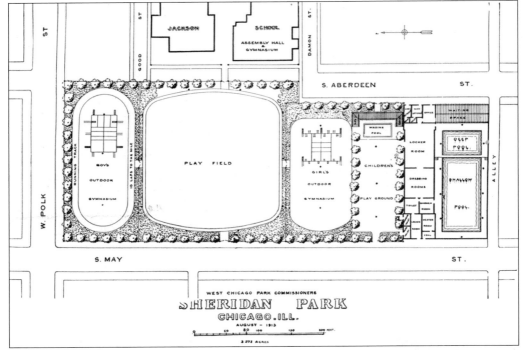

This is an architectural drawing of Sheridan Park from 1915, made by the West Chicago Park Commission. Notice that there are separate outdoor gymnasiums for boys and girls, a common feature at that time. There is a shallow and deep pool depicted on the right, and a nearby children's playground with a wading pool. This park is bounded by Aberdeen, Polk, and May Streets.

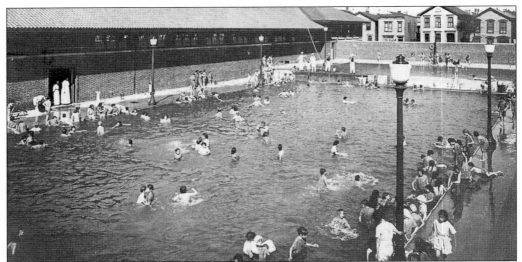

This is a 1916 photograph of the swimming pool in Sheridan Park on the near West Side. The park is located at 910 South Aberdeen Street. The land for the park was purchased between 1912 and 1914, and was originally known as Small Park #7. It was officially opened on July 25, 1914, and renamed in honor of Philip Henry Sheridan. The park contains a fieldhouse, gym, and assembly hall, in addition to the fields for baseball, football, and soccer.

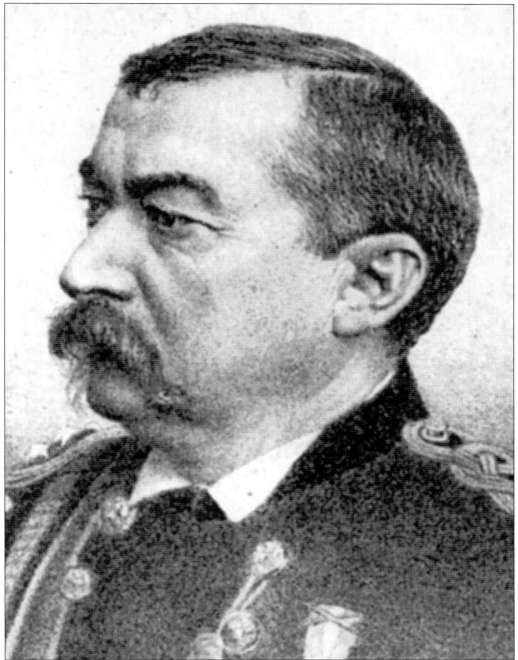

Philip Henry Sheridan (1831–1888) graduated from West Point in 1853 and became a Union General in the Civil War. After the war, he came to Chicago and founded the Washington Park Race Track. He also became a local hero after saving many lives during the Chicago Fire. A monument of Sheridan astride his horse, which depicts him in his famous 20-mile ride in the Civil War to win the battle against General Early for the Union troops, can be found at Belmont and Lake Shore Drive.

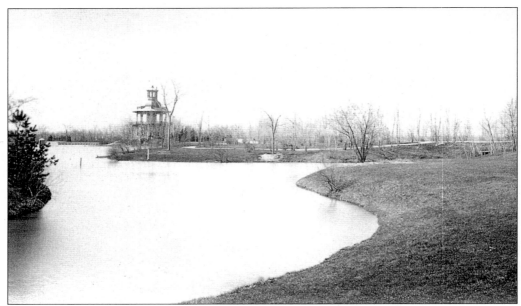

Humboldt Park, located at 1440 North Sacramento Avenue, was originally known as North Park. It was renamed in honor of German scientist Baron Friedrich Heinrick Alexander von Humboldt (1769–1859). When this "great" park was established in 1869, it was a dense forest. In 1871, the park commission hired architect William Le Baron Jenney to design a formal park. The opening ceremony took place on July 14, 1873. This is an early 1880s view in the park.

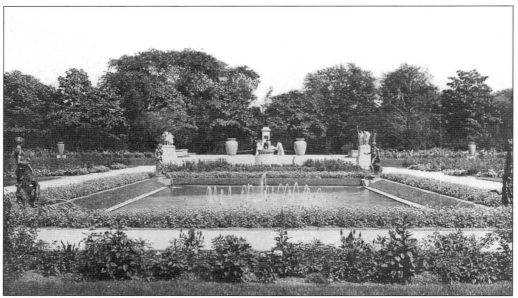

This is a scene of the Humboldt Park Rose Garden around World War I. The formal rose garden here is at its zenith. The garden is laid out in "naturalistic" style and planted with an eye to harmonious colors of pinks, reds, and yellows. It was said that over 24,000 plants and bulbs were used in the perennial garden for summer and fall plantings. These provided a colorful background for Edward Kenney's two bronze castings that were erected in 1911.

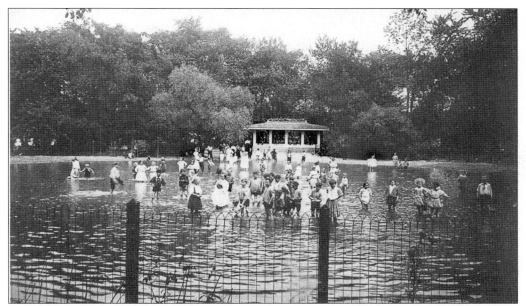

This is a summer scene of the wading pool at Humboldt Park in 1916. This photo demonstrates how early parks were intended to be used by neighborhood residents who rarely got beyond the city limits. Outdoor playgrounds and swimming pools provided recreational activities that were previously unknown to many people who might have never seen a body of water or a blade of grass.

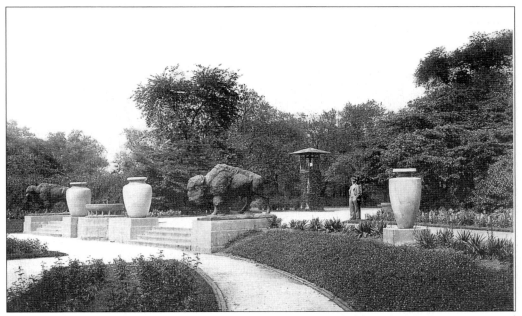

Two "Bison" stand at the east entrance to the garden at Humboldt Park near Sacramento and Division Streets. Generally referred to as buffalo, the bison face the sunken gardens. One bison stands with a lowered head, while the other stares straight ahead. They were created from models provided by sculptor Edward Kemeys (1843–1907) for the grounds of the World's Columbian Exposition. He is also known for the "lions" at the Art Institute.

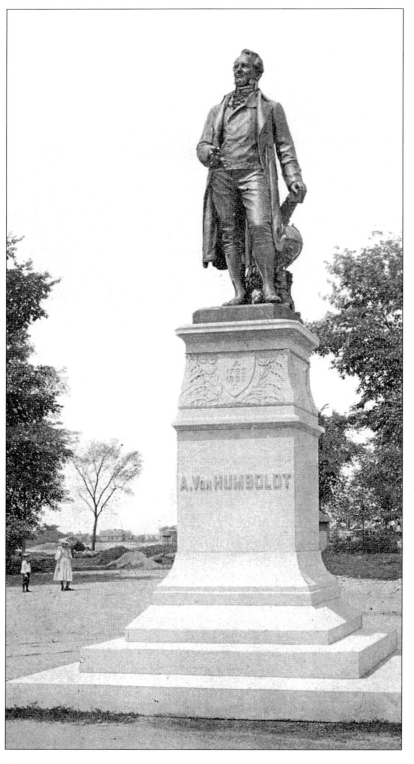

The bronze statue of Alexander von Humboldt is 10-feet high. It is located in Humboldt Park near the boat house. The sculptor was Felix Gorling. His design of von Humboldt includes these details: a twig in his right hand, a globe, a manuscript upon which a lizard sits, and some plants at his feet. These details symbolized his travels and his role in establishing the sciences of physical geography and geophysics. The statue was cast in Europe and donated by Francis J. Dewes.

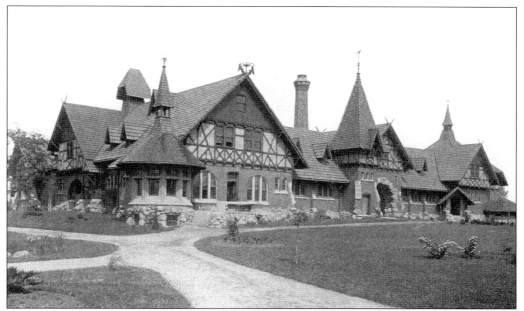

Humboldt Park is just over 206 acres in size. It was opened to the public in July of 1877, but at that time it was only partially completed. The German immigrants in Chicago were very happy with this park, since it was named after the great naturalist and scientist, Alexander von Humboldt. The main feature of the park is the great number and variety of trees, which provided a beautiful sight for early riders who rode their horses through the park. This is an early picture of the receptory and stables that were designed in 1896.

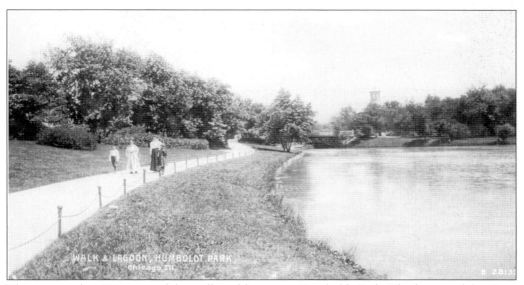

This is an early 1900s view of the walk and lagoon at Humboldt Park. The largest of the West Side parks, Humboldt was also considered one of the most beautiful. This view typifies the original picturesque ideal for a park by landscape designers. Boating was enjoyed in the summer at this park; a boat could be rented for a charge of 15 to 25¢ an hour in 1912. In the winter, skating replaced boating as the favorite activity.

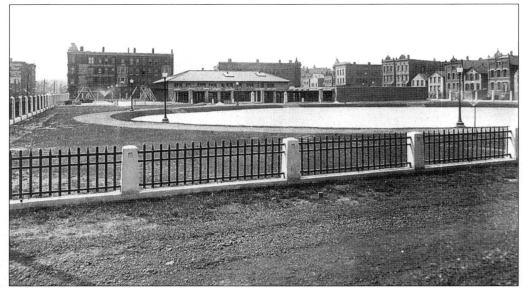

Pulaski Park, located at 1419 West Blackhawk Street, is named after the Polish patriot and military commander in the American Revolution, Casimir Pulaski (1748–1779). The land for the park was acquired between 1911 and 1915. The fieldhouse was designed by architect William C. Zimmerman (1859–1932), and erected in the park in 1914. The fieldhouse auditorium contains barrel-vaulted ceilings and a large mural designed by James J. Gilbert.

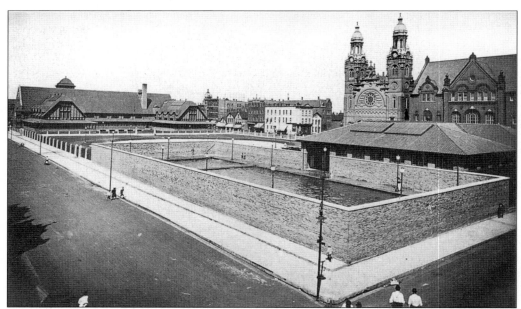

This is a photograph of the Pulaski Park swimming pool taken in 1916. The park was originally known as Small Park #5. It was renamed on January 22, 1913. It is nearly 4 acres in size and located in the First Ward. Today, the park continues to house facilities that accommodate sports and recreational activities. There is also an outdoor spray pool and an interactive water play area.

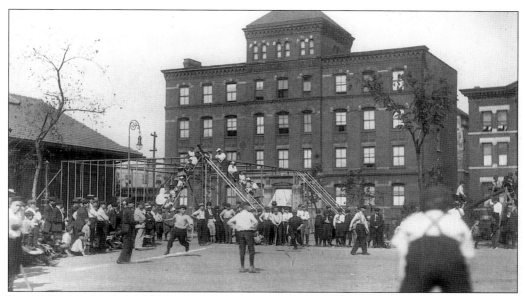

Seward Park, located at 375 West Elm Street, is named after William H. Seward (1801–1872). He was Secretary of State under Lincoln, and was seriously wounded by Lincoln's assassin, John Wilkes Booth (1838–1865). He recovered from his wounds and retained his position under the new administration of President Andrew Johnson. The land for the park was acquired in 1907, and the park was officially opened on July 4, 1908. The park's Prairie-style fieldhouse was designed by architect Dwight H. Perkins. This is an early view of a baseball game played by children in the park.

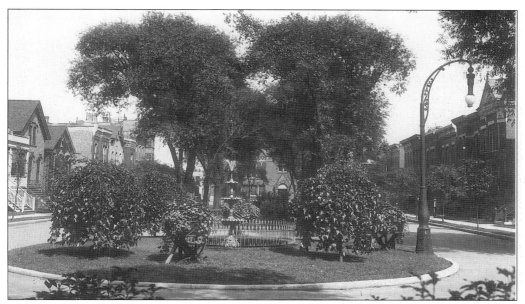

This is an early 1900s photograph of Campbell Park. The centerpiece of the park was a small but elegant fountain surrounded by a decorative wrought iron fence. This small 1.38 acre park was located in a fashionable neighborhood on Chicago's West Side between what is now Oakley Boulevard and Leavitt Street, one block north of Polk. The park no longer exists, and a Chicago Public School now stands on the site.

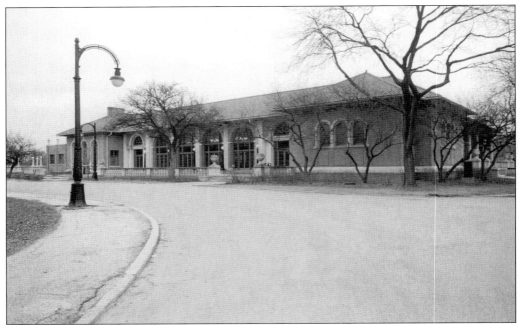

Columbus Park, at 500 South Central Avenue, is named after Christopher Columbus (1451–1506). The park was designed in 1920 by noted landscape architect Jens Jensen, and is one of the finest examples of his prairie vision for Chicago parks. Many of the park's original features and buildings still exist, including the entrance lanterns, waterfalls, nine-hole golf course, and the 20,000 square foot refectory building pictured here.

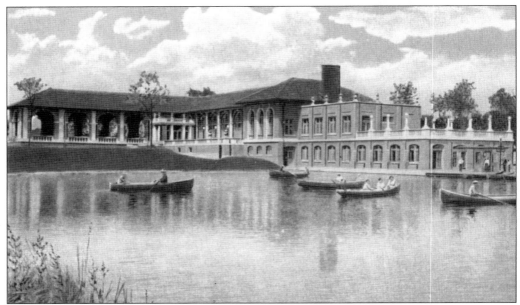

This is another view of the Columbus Park refectory. At one point, the refectory had a boat landing located on its eastern end. Dozens of boats were available for rental during the summer months. In the winter, the same area that was used for boating was used for ice skating.

This is a portrait of Jens Jensen (1860–1951), who was born in Denmark but emigrated to Chicago in 1884. He was one of America's greatest landscape designers and conservationists. His belief that city and park designs be harmonious with nature became a major theme in American landscape design. He was employed by Chicago's west park system and designed many of Chicago's parks. Long before environmental activists spoke out, he saw the need to preserve the wetlands native to the Midwest.

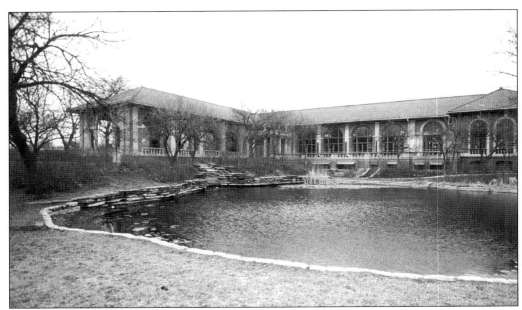

This scene represents another example of Jensen's prairie vision for Columbus Park. This may well have been one of the architect's favorite views, as it shows the meadow blending into the curved landscape. This scene merges two of Jensen's favorite prairie landscape symbols—water and open space.

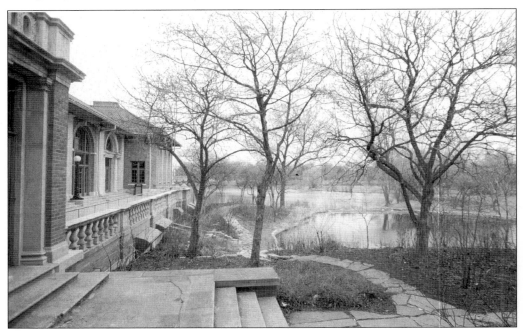

The Columbus Park refectory contains a dance floor, dining room, and a ceiling covered with ornate mosaics. The inside of the building expresses the Columbus theme of the park's namesake, with a mural on its west wall portraying the explorer with his three ships—the Nina, the Pinta, and the Santa Maria.

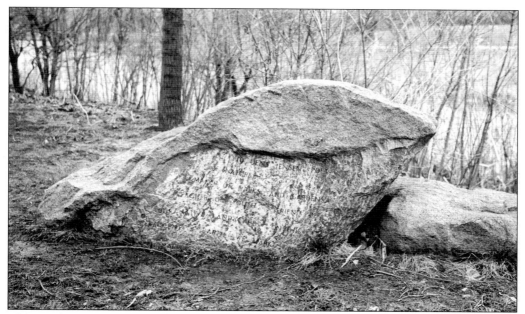

This is a photograph of the memorial boulder honoring Jens Jensen that can be found in Columbus Park. The boulder sits in a tranquil location overlooking the park and the water. It is engraved with an inscription honoring Jensen. The boulder was unveiled on September 24, 1960, to mark the 100th anniversary of Jensen's birth. The park is in the National Register of Historic Places.

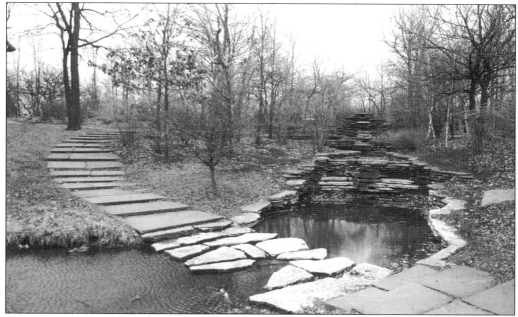

At the time he designed Columbus Park, Jensen used material excavated from the prairie river. This material was used in the construction of the walkway seen in this picture. There is a waterfall pictured in the foreground. Here people could watch the changing sky reflected in the waters below. It was this feeling of breadth and freedom that Jensen felt a prairie view should represent.

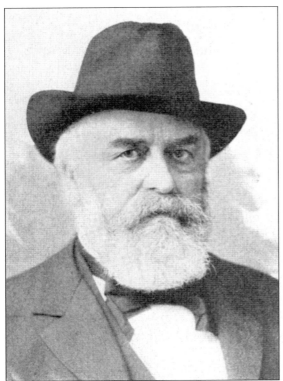

Carter Harrison Sr. (1825–1893) served five terms as Mayor of Chicago. Born near Lexington, Kentucky, he attended Yale and graduated from Transylvania Law School in 1845. He came to Chicago around 1855, and he became one of the first members of the Board of Commissioners of Cook County in 1871. It was said that he did more to enable Chicago's growth than any other man. He was assassinated on his own doorstep by a disgruntled office seeker.

The park at 1824 South Wood Street is named after Carter Harrison Sr. The first land for the park was purchased in 1912. Originally known as Small Park #6, it was renamed in honor of Harrison on January 22, 1913. The park's fieldhouse was built in 1928 by the architectural firm of Michaelsen & Rognstad. The Mexican Fine Arts Center Museum and a statue honoring Mexican revolutionary Emiliano Zapata (1879–1919) can be found in the park.

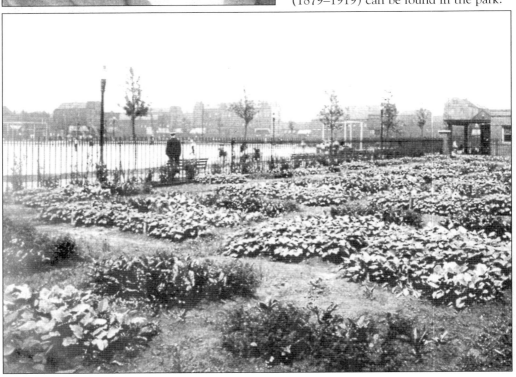

Henry Everett Greenebaum was born in Chicago before the Civil War. In 1877, he organized the banking firm of Greenebaum Sons, which became one of the strongest private banking institutions in Chicago. He also became a Chicago Alderman and a Commissioner of the West Chicago Park District. He was a member of the Lake Shore Country Club, the Standard Club, and the Press Club.

The park located at 4300 West Wabansia Avenue is named after Henry Everett Greenebaum (1854–1931). The land for the park was purchased in 1931, and was formerly known as Park #131. It was renamed in honor of Greenebaum on June 9, 1953. Encompassing over 1.5 acres, this rectangular shaped park is located in the 31st Ward.

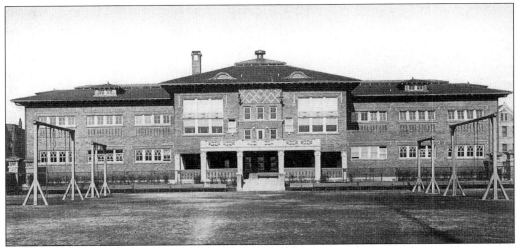

Holstein Park at 2200 North Oakley Avenue was once located in a predominately German neighborhood. The residents of the area named the park after Holstein, Germany. The land for the park was used as a cow pasture from 1854 until 1901, when the West Park Commission acquired it from the city. In 1911, construction of the park commenced. The park's Prairie-style fieldhouse pictured here was designed in 1911 by architect William C. Zimmerman (1859–1932).

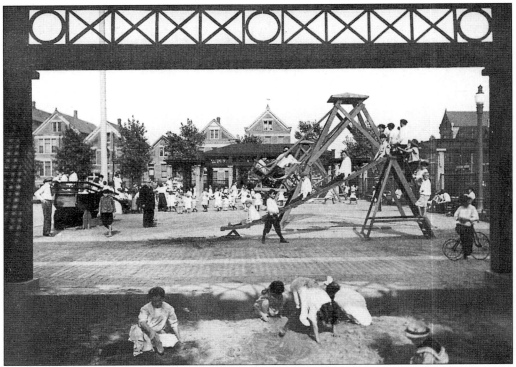

This photograph of Holstein Park was taken in 1916. Even today, this nearly 3-acre park is just as popular with neighborhood youngsters as it was then. There are numerous facilities for children of all ages including the original fieldhouse, a swimming pool, a wading pool, two gyms, a basketball court, and baseball fields.

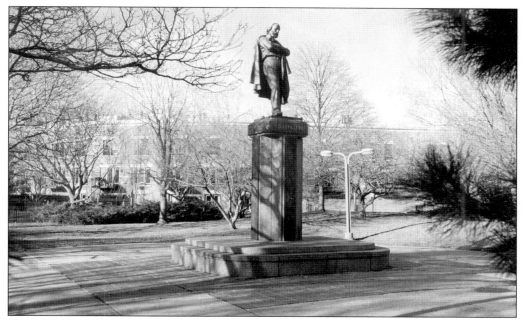

Garibaldi Park, located at 1520 West Polk Street, is named after Giuseppi Garibaldi (1807–1882), an Italian patriot and soldier. The land for the park was acquired in 1893, and the park was originally known as McLaren Park after Chicago businessman John McLaren (1836–1916). The park was renamed in honor of Garibaldi on April 12, 1979. A statue of Garibaldi by sculptor Victor Gherardi can be found in the park. The statue originally stood in Lincoln Park when it was unveiled in 1901.

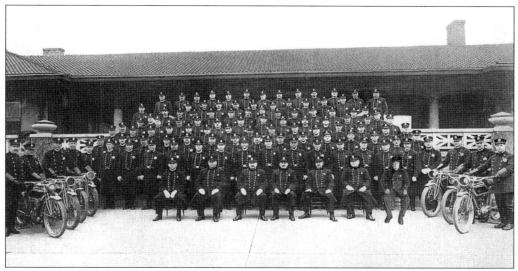

In 1915, the West Park Police Force consisted of 132 men. (This group was separate from the Chicago Police Force.) During that same year, they performed a variety of tasks ranging from arresting 317 people for disorderly conduct, to returning 61 lost children to their parents, or capturing 15 runaway horses that grateful owners were happy to reclaim. Seven people were also arrested for "stealing lilacs" in the park.

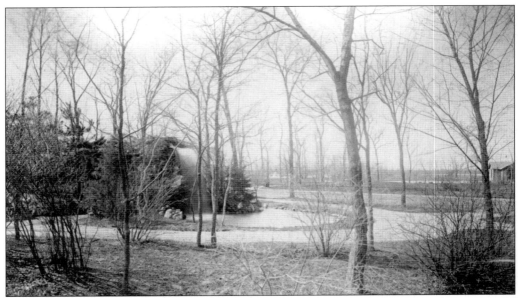

Garfield Park, located at 100 North Central Park Avenue, is named after the 20th President of the United States, James A. Garfield (1831–1881). The park was established in 1869, and the first 40-acre section was officially opened in August of 1874. It was originally known as Central Park, but often referred to as Middle Park because of its location between the other two "great" original West Side parks. It is the oldest of the three "great" original West Side parks, the other two being Humboldt and Douglas. This is a very early 1880s view in the park.

Garfield Park was designed by William Le Baron Jenney. As a young engineering student in Paris during the early 1850s, Jenny was greatly influenced by French parks and boulevards, and he attempted to model Garfield Park after them. In this 1880s view we see the artesian fountain in the foreground. The artesian well was sunk to a depth of 2,200 feet. It was the main attraction for many visitors who used to go there daily to drink the water. The well eventually ran dry and was removed.

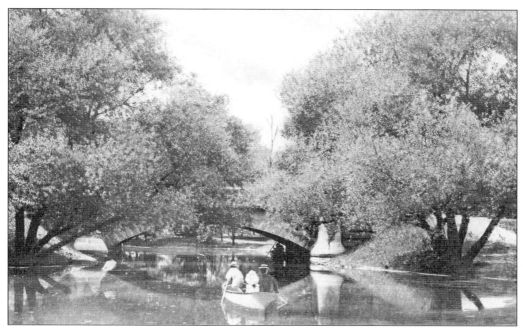

Boating in Garfield Park was a favorite pastime in the late 1800s and early 1900s. Boaters were drawn there because the 184-acre park contained a double lake, which was divided only by a narrow peninsula of land. The lower lake, which was designed to be simplistic and rural, attracted many people on weekends and holidays as the photo indicates. In contrast, the upper lake was more formal in character and design.

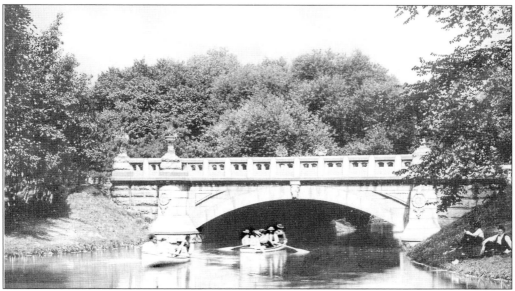

This is an early boating scene in Garfield Park. Here we see two groups of boaters near the large arched stone bridge. Onlookers on the right leisurely enjoy the view from the bank. Notice the ornate columns of the bridge that architect Jenney utilized to reflect the European "flavor" he intended to bring into his park designs.

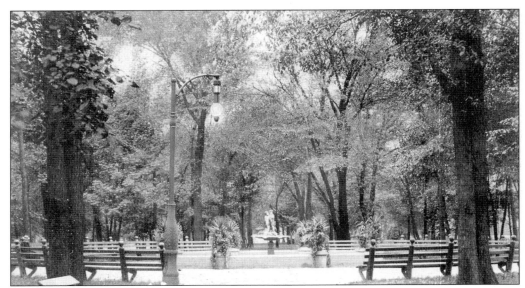

This is an early photograph of one of the many fountains that used to grace Garfield Park. Tall trees, shrubbery, elegant street lights, and ornate wooden benches surrounded this fountain. Thus, this park provided passive recreation for residents who wished to relax or escape from the tensions of the crowded city.

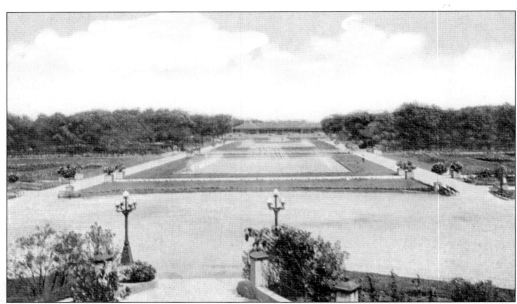

This is an early 1900s view in Garfield Park of the water courts and flower beds, looking north from the bandstand. Landscape architect Jens Jensen linked the bandstand to the western lagoon by constructing a large formal garden with reflecting pools running north. Notice the refectory building at the far end of the water courts—both of these have since been removed

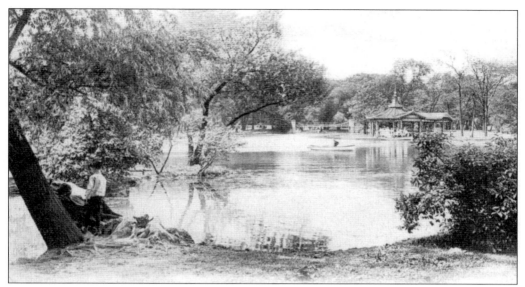

Lake scenes such as this were once quite common in Garfield Park. This vista view utilizes light and shadow to enhance the perspective as seen from a young boy on the left. In the distance, a small bridge beckons the boater in front of it. This picture represents the tranquil scenes that once abounded in the park.

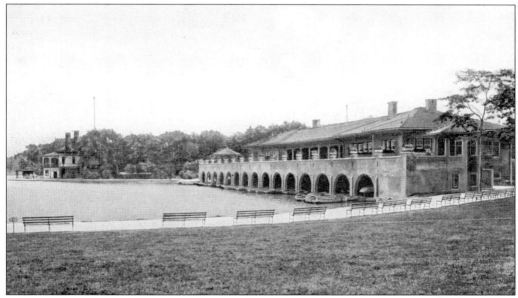

At one time, Garfield Park was famous for its leisure activities—primarily boating. This is a picture of the boat house that once existed in the park. People would come from all areas of the city during the summer months to rent boats or sit on the many benches that faced the water. Sadly, Garfield Park has not seen a boat on its waters in many years.

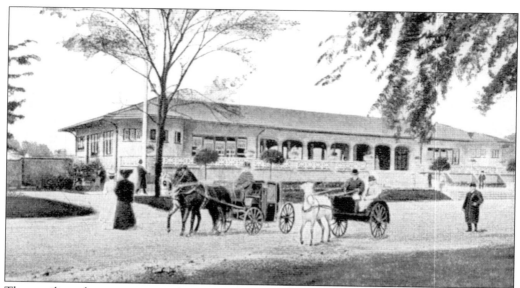

The pavilion that is represented in this view of Garfield Park no longer exists. At one time, however, it was one of the main attractions in the park. This early 1900s scene was typical for the time period. People strolled through the grounds and took buggy rides past the pavilion on their way through the park.

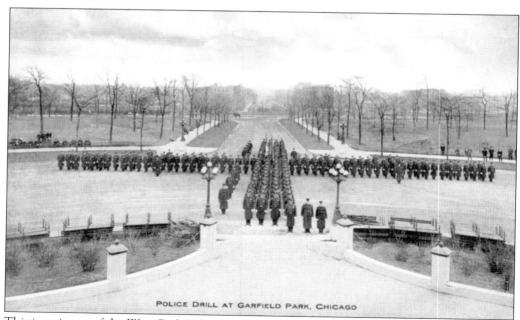

POLICE DRILL AT GARFIELD PARK, CHICAGO

This is a picture of the West Park Police Force in the early 1900s. It was taken during a practice drill in Garfield Park to demonstrate the size and efficiency of the force. This view (facing north) was taken from the park's bandstand. In 1915, this police force numbered 132 uniformed men. The park district no longer has its own separate police force.

This is an early photograph of the stone bridge in Garfield Park. It was intended to exemplify the picturesque scenes to be found in the park before the turn of the 19th century. On the right, notice the horse and buggy under the trees. In the foreground, the reflection of the bridge can be seen in the water.

This is a scene of the Garfield Park Conservatory about the time of the First World War. Serving the West Side, the park was laid out by renowned architect, William Le Baron Jenney. Jens Jensen, the West Park systems' chief landscape architect, was later responsible for implementing the conservatory plan. The plan replaced small greenhouses with one economical, centrally located facility. Pictured here, the conservatory and tennis courts are examples of the combination of beauty and recreation.

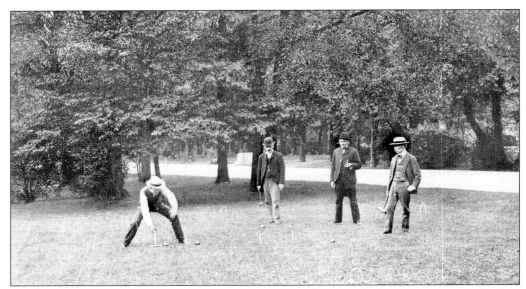

This is a view of Garfield Park prior to 1905. In the foreground, these men are involved in playing a game of croquet. One of the park's most interesting features was this lush open meadow. Croquet parties, as well as picnics, and military parades once abounded here. It should be remembered that parks such as this one were meant to provide city residents with open breathing places that contained grass and trees as well as ponds and fountains.

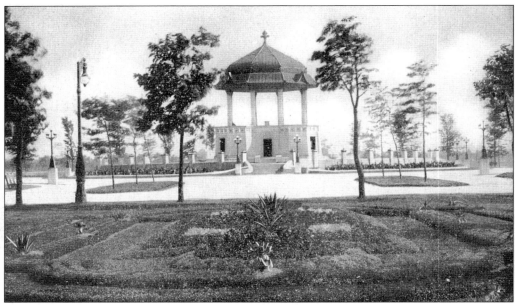

The bandstand at Garfield Park no longer hosts concerts, although at the turn of the last century, a 100-piece orchestra frequently performed there. Designed by Joseph Lyman Silsbee in 1896, the bandstand's style was Arabian with a copper roof and calligraphic mosaic panels. During 1916 alone, nine concerts were performed there. The bandstand remains in the park to this day.

This is a photograph of a replica of Ft. Dearborn that was once located on an island in Garfield Park. The original Ft. Dearborn, however, used to stand near Michigan Avenue and Wacker Drive. The replica was intended to remind people of Chicago's early history. Few people remembered that a regiment of United States soldiers built the old Ft. Dearborn as early as 1803.

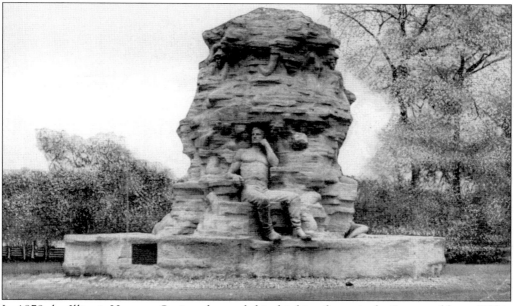

In 1879 the Illinois Humane Society donated this drinking fountain for "man and beast." This drinking fountain at Garfield Park no longer stands today. As a matter of fact, only a portion of Garfield Park's original structures remain. Composed of slightly over 184 acres, the park was once a picturesque landscape of beautiful vistas, winding lanes and a rich sculpture collection. The fountain was removed after it began to deteriorate due to age and harsh elements.

47

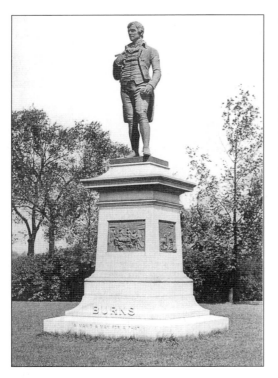

This statue in Garfield Park of Robert Burns (1759–1796) was cast in Edinburgh, Scotland, and unveiled in Chicago on August 26, 1906. The sculptor was W. Grant Stevenson, who tried to capture the spirit of the Scottish national poet by showing Burns holding a copy of his poems. The statue is bronze and is 10-feet high. Famous lines from some of Burns's poems were cut into panels on the base of the statue but have since been removed.

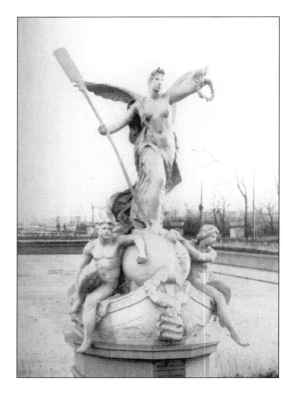

This is a picture of a statue once found in Garfield Park. It was sculpted by Cratt and was called the "Glorification of Discovery." This statue can no longer be found in the park. In fact, the majority of Garfield Park's rich outdoor sculpture collection has been removed. At the present time, only the outdoor statues of Robert Burns and Abraham Lincoln remain in the park. There are several other statues, but they are all located inside the park's conservatory.

Two

PARKS OF THE SOUTH SIDE

Chicago's South Side parks have a rich and varied history. The first park on the South Side was Ellis Park, which was established in 1855. Like the Commissions of Lincoln Park and the West Parks, the Board of South Park Commissioners was organized in 1869. Determined to create parks of picturesque beauty, the commissioners retained the services of Frederick Law Olmsted (1822–1903), the father of American landscape architecture, and his associate, Calvert Vaux (1824–1895) to design Jackson Park, the Midway Plaisance, and Washington Park in 1871.

The South Side contains some of the most historically significant parks in Chicago. Jackson Park was the main site of the Columbian Exposition in 1893. More than 27 million people came from around the world to take in the spectacular sights and exhibits. During the exposition, the Midway Plaisance housed many amusements including the original Ferris wheel, which was designed by Washington Gale Ferris (1859–1896). Even today, Washington Park continues to be one of the finest examples of Olmsted's landscape vision in Chicago. Finally, many examples of Daniel Burnham's architecture are reflected in the fieldhouses found in such parks as Armour Square, Cornell Square, Palmer, and Sherman to name but a few.

Like the parks of the North and West Sides, the South Side parks also contain a collection of monuments and sculptures. A statue of Carl von Linne stands in the Midway Plaisance. A bronze bust of Paul Cornell is located in the fieldhouse of Cornell Square Park, while a bust of Sun Yat-Sen resides in its own park in Chicago's historic "Chinatown." Several other parks contain their share of monuments, including Burnham, Jackson and Washington.

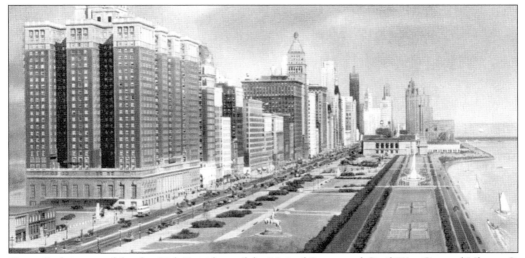

Grant Park is named for the 18th President of the United States and Civil War General Ulysses S. Grant (1822–1885). The park is 303 acres in size and bounded by Randolph Street to the north, 14th street to the south, Michigan Avenue to the west, and Lake Michigan to the east. Because of its location on the downtown lakefront, the park is often referred to as "Chicago's front yard."

This is a late 1920s view of the entrance to Grant Park. The statues and pillars still mark the entrance to the park, but the grand plaza and staircase were removed when Congress Parkway was extended east through the park in the 1950s. Today the park contains several major attractions including the Art Institute, Buckingham Fountain, Monroe Street Harbor, the James Caesar Petrillo Music Shell, the Daniel L. Flaherty Rose Garden, the Goodman Theater, the Field Museum of Natural History, and many famous sculptures.

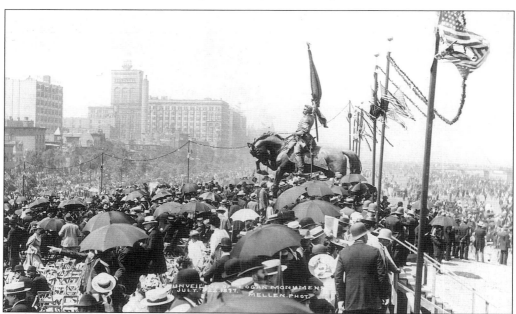

The General John A. Logan (1826–1886) memorial is found in Grant Park near Michigan Avenue and 9th Street. Logan served in the Civil War and in the U.S. House of Representatives and Senate. He holds a flag high as a sign of inspiration to rally his troops. The statue was designed by Augustus Saint-Gaudens and Alexander Phimister Proctor. Saint-Gaudens did the figure while Proctor did the horse. This photo was taken at the unveiling of the memorial on July 22, 1897. Mrs. Logan wept at the sight of the many veterans who marched passed the statue in tribute to her husband.

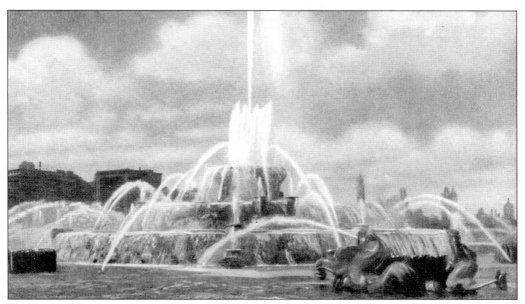

Buckingham Fountain is one of the main attractions in Grant Park, especially during the summer months. Although it is modeled after the Latona Fountain in the garden of Versailles, France, it is more than double the size. The fountain was a gift from Kate Buckingham (1858–1937) in memory of her brother Clarence (1854–1913). The statue was unveiled on August 26, 1927.

This is a photograph of the park in 1889 when it was still known as Lake Park. Adler & Sullivan's Auditorium Building, which looms boldly in the background, was just nearing completion. In 1901, the park was renamed in honor of Ulysses S. Grant. The auditorium building still overlooks the park today.

Abbott Park, located at 49 East 95th Street, is named after Robert Sengstacke Abbott (1868–1940), who was the son of slaves and founder of one of Chicago's first and most prominent African-American newspapers, the *Chicago Defender*. The land for the park, over 22 acres in size, was purchased in 1949. Today it is the site of the annual Kwanzaa Summer Festival.

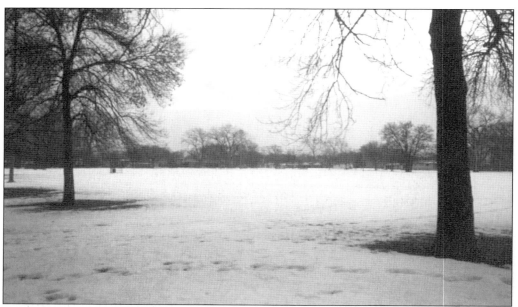

Ada Park at 11250 South Ada Street takes its name from the street on which it is located. The street name was selected to honor Ada Sawyer Garrett (1856–1938), the granddaughter of prominent attorney and Chicago real estate developer, Justin Butterfield (1790–1855). The land for the park was acquired in 1930. It was originally known as Loomis Street Park after Horatio G. Loomis (1814–1900), an early resident and director of the Chicago Board of Trade. On September 27, 1934, the park was renamed in honor of Ada.

Adams Park at 7535-59 South Dobson Avenue is a small triangular shaped park, located in the 5th Ward on the South Side. According to local history, the park may have been named after John C. Adams, an official with the old Cornell Watch Company. This company was located near the park. The park is a small passive recreation area that contains no facilities.

This is an early view in Woodland Park at 35th and Cottage Grove. The focal point of the photograph is the tomb and monument of Stephen A. Douglas. The tomb is built on land that was once part of the Douglas estate. This monument is one of the oldest and tallest in Chicago. This section of the park is maintained by the State of Illinois and is now known as the Douglas Tomb State Memorial Park.

Aldine Square Park was an exclusive private park located on Vincennes Avenue between 37th and 39th Streets. The 1.5-acre park was surrounded by elegant graystone homes that were owned by some of Chicago's most prominent citizens. The owners of the homes surrounding this private park were assessed a special tax for the maintenance and upkeep of the park. Both the park and the homes surrounding it were designed by the architectural firm of Cudell and Blumenthal in the 1870s.

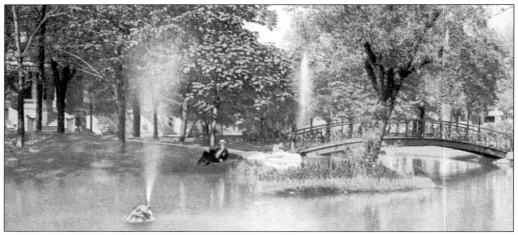

This view of Aldine Square Park in the 1890s showcases the artificial lake, wrought iron bridge, and fabulous elm trees that stood in the park. The park and the homes around it were given a distinctive European feel by the park's chief architect Adolph Cudell, who hailed from Germany. Over the years many residents left the area, and Aldine Square gradually fell into a state of disrepair. The park and the homes were eventually razed in the name of urban renewal. A housing project now stands on the site.

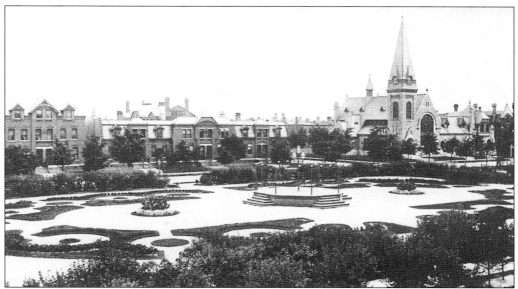

Arcade Park at 11132-56 South St. Lawrence Avenue, located in the Pullman neighborhood, is so named because of the Arcade Row houses that face the park. The land for the park was donated to the city in 1910 by the Pullman family. The park, which is located next to the Hotel Florence, contains a small memorial marker that designates the park as a Chicago landmark.

Tuley Park, located at 501 East 90th Place, is named after former Cook County Circuit Court Judge Murray F. Tuley (1827–1905). The land for the park was acquired between 1909 and 1911. The park was originally known as Park #18. It was later called Burnside Park because of its location in Burnside, which is named after Civil War General Ambrose E. Burnside (1824–1881). The park contains a large and elaborate fieldhouse that was built in the 1920s. The fieldhouse contains a branch of the Chicago Public Library. Over 20 acres in size, this regional park is located in the 6th ward.

Armour Square Park at 3309 South Shields Avenue is named after Philip Danfourth Armour (1832–1901), an industrialist who made a fortune in the meat packing business. The land for the park was purchased in 1904 and designed by the Olmsted Brothers. The opening ceremony was held on March 31, 1905. The park's fieldhouse was designed by Daniel Burnham. Armour Square Park stands in the shadows of Comiskey Park, where the Chicago White Sox play their home games.

Phillip Danforth Armour was born in Stockbridge, New York. He later came to Milwaukee, Wisconsin, where he formed a partnership in the grain and commission business. This ended in 1863, and he embarked into the packing industry. The supply of meat was low during the Civil War, and Armour undertook to supply the needs of the Union forces. The firm of Plankinton and Armour was soon one of the busiest in the country. In 1867, he organized Armour and Company in Chicago.

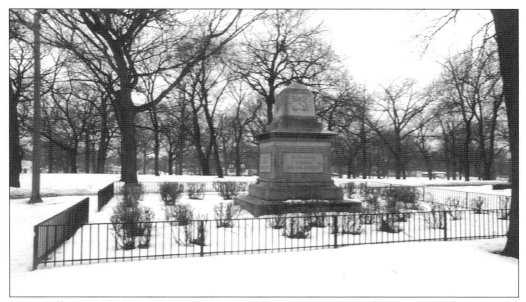

West Pullman Park, located at 401 West 123rd Street, is so named because it is found in the West Pullman area, which is named after American industrialist George M. Pullman (1831–1897). The land for the park was acquired in 1914 and 1915. It was named on October 7, 1915, and officially opened on July 4, 1916. A large war monument can be found in the park, which stands on what used to be farmland. The eastern portion of the park is covered with dozens of beautiful oak trees.

Bohn Park, located at 1966-88 West 111th Street, is named after the first president of the Calumet Park District, Henry J. Bohn. He was born in Ohio in 1855 and came to Chicago in 1876. The park was originally known as "Depot Park" and "The Common." The 111th Street Metra train station is located in the park, which is why it was once called "Depot Park." On December 14, 1935, it was renamed in honor of Bohn. The park is located across the street from the Morgan Park Presbyterian Church.

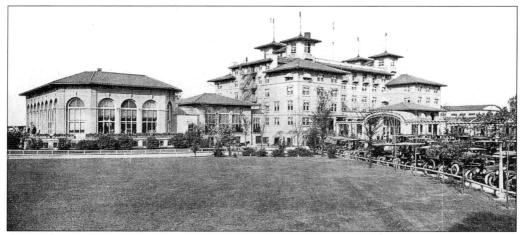

South Shore Cultural Center Park (the South Shore Country Club) at 7059 South Shore Drive was designed by the architectural firm of Marshall and Fox and completed in 1916. The club, which featured a nine-hole golf course, tennis courts, riding stables, and a secluded beach, was considered to be one of the finest private country clubs in Chicago. The park district acquired the property in the early 1970s and opened the grounds to the public.

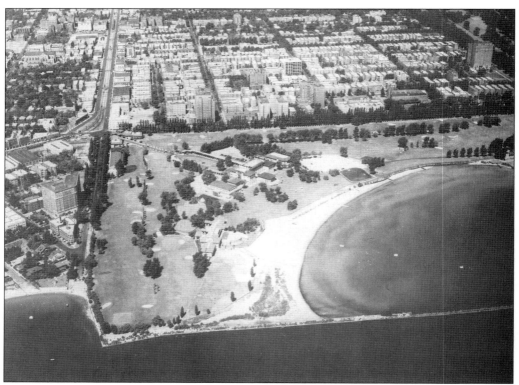

This is an aerial view of the South Shore Country Club in 1936. Now known as South Shore Cultural Center Park, it is one of the park district's showcase properties. The clubhouse has been converted into the park's headquarters and contains two magnificently restored ballrooms that are used for a variety of functions. The property is listed on the National Register of Historic Places.

Ellis Park, located at 648 East 37th Street, is named after Samuel Ellis, who operated the Ellis Inn at what is now the southwest corner of Lake Park Avenue and 35th Street in the 1830s and 1840s. He also owned most of the land in the area. On March 21, 1855, he deeded the initial land for the park to the city. Over the years the park was enlarged as additional land was acquired. In this photograph, the Sixth Presbyterian Church constructed in 1879 overlooks the park.

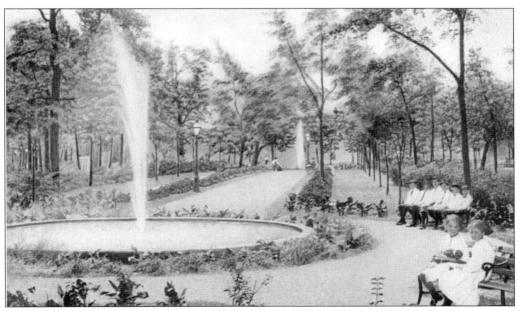

Ellis Park is one of the oldest existing parks in the City of Chicago. In its heyday it was a beautiful park that contained fountains, large trees, well-manicured lawns, and pathways for strolling. Located in a prestigious area on Chicago's South Side, the park was surrounded by elegant homes. Residents of the neighborhood flocked to the park in large numbers to enjoy the picturesque landscape. This photo shows an early 1900s view of the park in its full glory.

Bessemer Park at 8930 South Muskegon Avenue is named after Sir Henry Bessemer (1813–1898). He discovered the process that perfected the making of steel. This process made high-grade steel commercially available and allowed builders to create steel frames which could support massive weight, thus permitting the construction of skyscrapers. The land for the park was acquired in 1905 and officially named Bessemer Park on August 17, 1907. The park's fieldhouse was designed by Daniel H. Burnham.

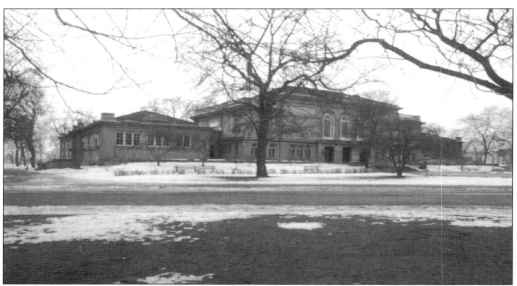

Calumet Park, located at 9801 South Avenue "G", was established in 1904. Nearly 200 acres in size, it is built on landfill made from slag from the old steel mills that once dominated the area. The Classical Revival-style fieldhouse was designed in 1922. The fieldhouse contains one of the largest model railroads in the world. The park also contains a large beach and a United States Coast Guard Station. The park is located between 95th Street to the north and 102nd Street to the south, lying east of Avenue G and the railroad tracks.

The land for Trumbull Park was acquired in 1908 and 1909. The park was designated as Park #16 and later named Irondale Park, because the area was famous for its steel industry and steelworker residents. The name of the park was changed to Trumbull Park on August 15, 1917. A formal dedication ceremony was held on September 3rd of that same year. The path shown here lined with old trees is a view from the main entrance of the fieldhouse looking north.

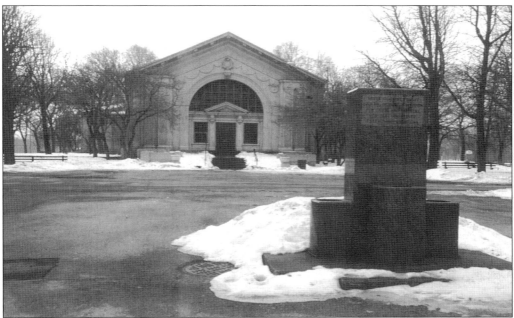

Trumbull Park at 2400 East 105th Street is named after former Illinois Supreme Court Justice and United States Senator Lyman Trumbull (1813–1896). The park was originally designed by the Olmsted Brothers, and the park's Classical Revival-style fieldhouse was built in 1915. Notice the fieldhouse in this picture and the World War I memorial located just north of it.

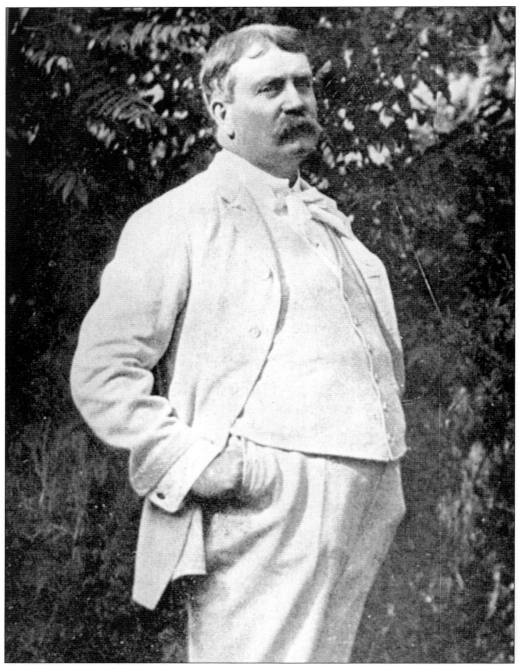

Daniel H. Burnham (1846–1912) was an architect and city planner. He designed many buildings in Chicago, and he was the chief architect for the Chicago World's Fair of 1893. His plan of Chicago, which was published in 1909, called for numerous public works projects designed to transform the city into a "Paris on the Lake." The plan helped to create a series of lakefront parks. This is an early 1900s photograph of Burnham on the terrace of his Evanston home. Burnham is buried in Graceland Cemetery on the city's North Side.

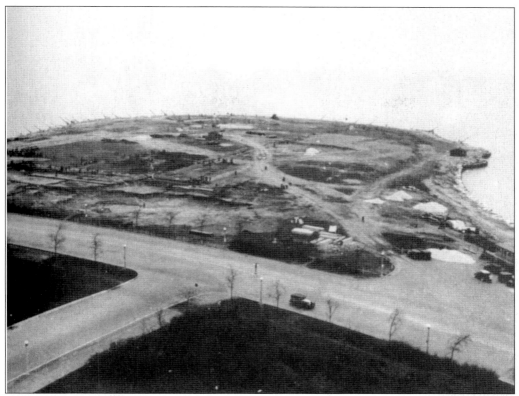

Promontory Point at 5491 South Shore Drive is one of the main attractions in Burnham Park. "The Point" was created in the 1920s by landfill, as can be see in this photograph. In 1936, noted landscape architect Alfred Caldwell designed the park. In 1937, architect E.V. Buchsbaum designed the castle-shaped lannon stone fieldhouse. Promontory Point was completely refurbished and rededicated in a ceremony on May 30, 1992.

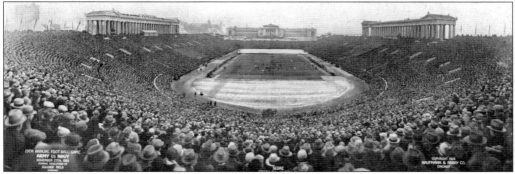

Burnham Park is named for Daniel H. Burnham. Located between 14th and 56th Streets along the lakefront, and connecting Grant Park with Jackson Park, at 585 acres it is the second largest park in the City of Chicago. The park was officially named Burnham Park by the South Park Commission on January 24, 1927. Burnham Harbor, McCormick Place, and Soldier Field can all be found in the park. This is a picture of the 1926 Army vs. Navy game that was held in Soldier Field and attended by 110,000 fans.

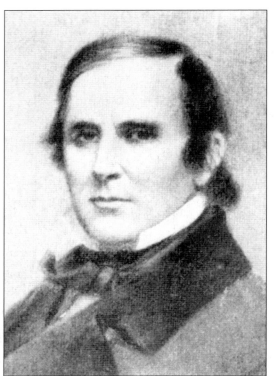

William B. Ogden (1805–1877) was the first mayor of Chicago. He was born in the dense forest of Delaware County, New York. His father died when he was 16, and he had to care for his mother and younger brothers and sisters. In 1835 at the age of 30, he came to Chicago to represent the American Land Company. A few years later he was elected mayor. He built the first Chicago railroad (Galena/Chicago Union), which is now the Chicago and North Western.

Ogden Park, located at 6500 South Racine Avenue, is named after William Butler Ogden. He made a fortune in the real estate business and also founded the Chicago and North Western Railroad. When the land for the park was purchased in 1903 and 1904, it was mostly farmland. The park was planned by the Olmsted Brothers, and the buildings were designed by Daniel H. Burnham. The park was named on August 17, 1904, in honor of Ogden, and it was opened to the public in 1905.

This is a photograph of the Paul Cornell bust that is found in the main lobby of the Cornell Square Park fieldhouse. This brass bust was placed in the park by his family on March 4, 1929, to commemorate the 25th anniversary of his death. A crowd of a few hundred people, many friends and relatives of Cornell, attended the unveiling.

Cornell Square Park at 1809 West 50th Street is named after the founder of Hyde Park, Paul Cornell (1822–1904). He was a member of the South Park Board of Commissioners for 13 years, and during this time, he promoted the creation and expansion of Chicago parks. He died in Chicago in 1904 and is buried in Oak Woods Cemetery. The land for the park was purchased in 1904. The park was laid out by the Olmsted Brothers, and the Prairie-style fieldhouse was designed by Daniel Burnham.

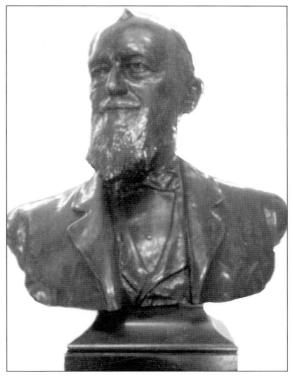

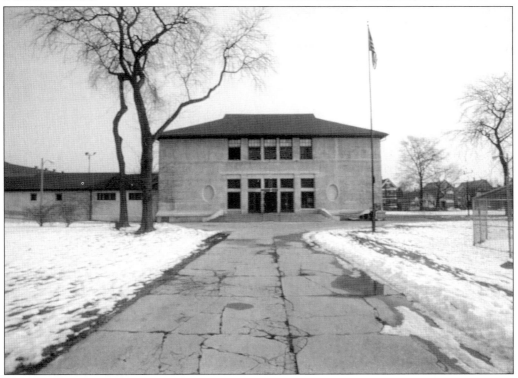

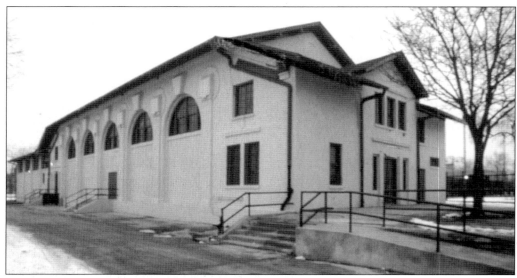

Palmer Park, located at 201 East 111th Street, is named after Chicago's merchant prince and father of State Street, Potter Palmer. The land for the park was acquired on January 30, 1904. The park was designed by the Olmsted Brothers, and the fieldhouse was designed by architect Daniel Burnham. It was named in honor of Palmer on August 17, 1904, and opened to the public on October 9, 1905. A crowd of about 2,000 people attended the opening.

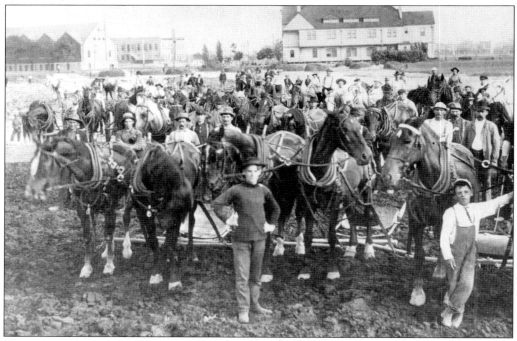

This is an early 1900s photograph of the workers during the construction of Palmer Park. It took nearly two years to complete the construction of this 40-acre park. Holy Rosary Church, which still stands on the corner of Indiana Avenue and 113th Street, can be seen in the background on the left.

Potter Palmer (1826–1902) was a dry goods merchant and business associate of Marshall Field. He revolutionized the dry goods business by being the first to offer credit and money-back guarantees. He was also a real estate investor and a commissioner of the South Park Board. He is most famous for his hotel business, and the Palmer House Hotel still stands today on State Street. Palmer was one of the incorporators of the board of trade and one of three creators of the World's Columbian Exposition. He is buried in Graceland Cemetery on the city's North Side.

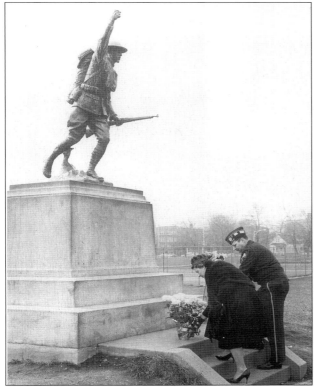

Chicago Parks are filled with monuments and markers honoring the men and women who served in the United States Armed Forces. Two Chicagoans are pictured here placing flowers at the base of the Doughboy Monument in Palmer Park on Veterans Day in 1962. The Doughboy Monument no longer stands in Palmer Park, but Veterans Day rituals such as this are still carried out at other parks throughout Chicago.

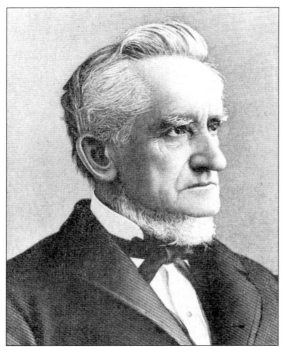

Dr. Nathan Davis (1817–1904) was a scholar and philanthropist. He became a physician at age 20 and was one of the founders of the American Medical Association. He is considered one of the most famous men in early Chicago medical history. He was also one of the founders of Northwestern University as well as the Chicago Historical Society.

Davis Square Park at 4430 South Marshfield Avenue is located in the old Union Stock Yards district. The park is named after Dr. Nathan Davis. The land was acquired in 1904 and designed by the Olmsted Brothers. The park opened on May 13, 1905, and a large crowd attended the opening. Catering to area residents who worked in the Stock Yards, the fieldhouse, which was designed by Burnham, contained gyms, showers, a cafeteria, a library, and meeting rooms. Towels and soap were provided at no charge, and meals were provided for a cost. Nurses and doctors provided free health care.

Melville Weston Fuller (1833–1910) was born in Augusta, Maine, and could trace his ancestors back to the pilgrims. Fuller was admitted to the bar in 1856 having completed his studies at Harvard Law School. That same year he came to Chicago to practice. Within two years of his arrival, he argued his first case before the Supreme Court of Illinois. From that time, until being appointed the Chief Justice of the United States Supreme Court, he was engaged as counsel in nearly all the important actions that stand as landmarks in jurisprudence.

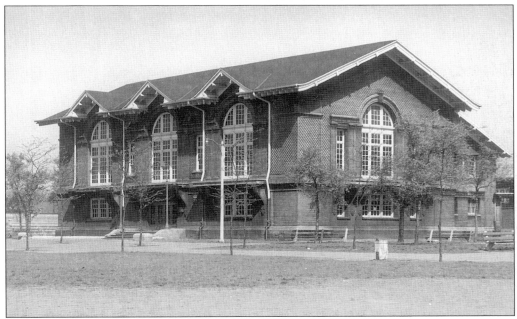

Fuller Park, located at 331 West 45th Street, is named after former Chicago lawyer and Chief Justice of the United States Supreme Court, Melville W. Fuller. The park was laid out by the Olmsted Brothers in 1905 before the land was acquired in 1908. In 1910, Burnham designed the park's Classical Revival-style fieldhouse, which is considered to be one the most beautiful in the city. The fieldhouse auditorium is decorated with murals done by Works Projects Administration (WPA) artists in the. A small bust honoring Fuller was unveiled in the park on July 23, 1913.

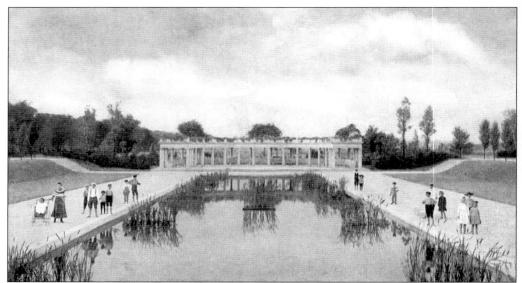

Gage Park at 2411 West 55th Street is named after George W. Gage (1812–1875), who purchased the Tremont Hotel in 1853. He was a frequent host to Abraham Lincoln and other politicians and celebrities. In 1863, Gage was elected to the Illinois House of Representatives and later was a Chicago Alderman in the 1st ward. In 1869, he ran for mayor but lost. He was an original member of the South Park Commission from 1869 until his death in September of 1875. The park was officially named in honor of Gage on October 26, 1875.

The first land was acquired for Gage Park in 1873, but the park continued to grow insize as additional land was purchased up until 1930. Gage Park was designed by the South Park Commission in 1905, and the fieldhouse was erected in the 1920s. A branch of the Chicago Public Library was located in the fieldhouse from 1928 until 1955. Today the park is nearly 30 acres in size.

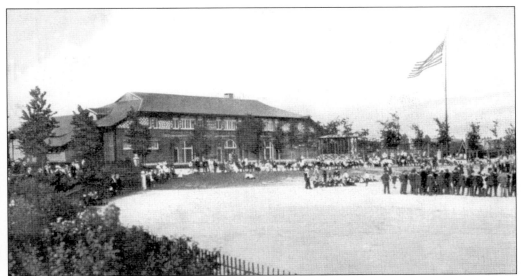

Hamilton Park at 513 West 72nd Street is named after Alexander Hamilton (1755–1804), an American statesman, soldier, and the first United States Secretary of the Treasury. Mortally wounded in a duel with Aaron Burr (1756–1836), his brilliant career ended prematurely. The land for the park was purchased in 1903 and 1904. The park was designed by the Olmsted Brothers, and the Classical Revival-style fieldhouse was built in 1904 by architect Daniel H. Burnham (1846–1912). The park was officially opened on April 7, 1905.

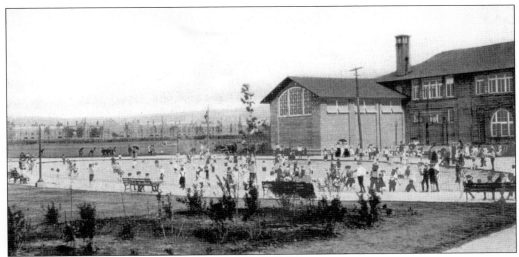

This photo shows the wading pool in Hamilton Park. These pools were typical features of Chicago's early neighborhood parks. Children from the crowded city could come here to frolic in the water, while their parents gathered around the pool or sat on the benches to watch and relax.

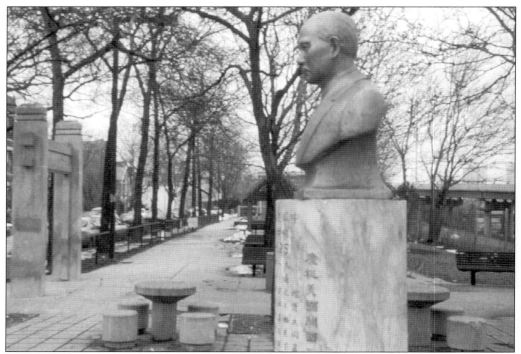

Sun Yat-Sen Park, located at 251 West 24th Place, is named after Chinese revolutionary Sun Yat-Sen (1866–1925). He helped to create the Republic of China, but died before unification was complete. The land for the park was acquired between 1905 and 1910. The park was originally more than 7 acres in size, and was known as Hardin Square in honor of General John J. Hardin (1810–1847). The park was reduced to less than an acre in size when the Stevenson Expressway was built. The bust of Sun Yat-Sen in the park was donated by the Lion's Club of Taiwan.

Grand Crossing Park at 7655 South Ingleside Avenue is so named because it is located in the area known as Grand Crossing. The name came into use due to the heavy traffic from the Illinois Central, Lake Shore, and Michigan Southern railroad tracks in the mid 1800s. The land for the park was acquired between 1908 and 1910. The park was officially named Grand Crossing Park on July 16, 1913, at the urging of the Grand Crossing Business Men's Club. The park's fieldhouse was erected in 1915.

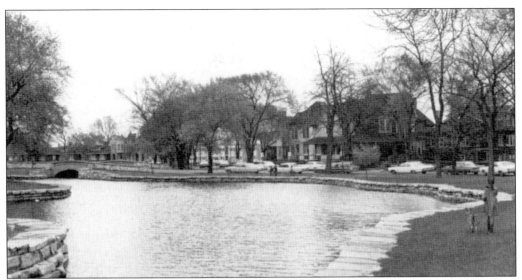

Auburn Park, located at 406 West Winneconna Parkway, received its name from the three men (Sanford McKnight, Alfred Manning, and Henry Mather) who donated the land to the city. They selected the name because the land was located in the community of Auburn Park, platted in 1872. The park was donated to the city in two pieces, the first in 1911, and the second in 1913. The land was donated under the condition that it be used as a park by the name of Auburn.

Hurley Park at 1901 West 100th Street is named after Father Timothy Hurley (1870-1946), who was the pastor of the St. Barnabas Church located near the park from 1924 until his death. The park was established in 1924 and was originally known as 100th Street Park and later as Shamrock Park. Hurley Park is famous for its large oak trees, and is located in the Longwood Drive Historic District—a marker has been placed in the park by the city to serve as a reminder of this.

This is a 1950s view of Shedd Park's Prairie-style fieldhouse, which was designed in 1916 by architect William Drummond (1876–1946), who was an apprentice to Frank Lloyd Wright (1867–1959). The fieldhouse, which is a National Historic Landmark, is considered by some to be one of the finest examples of Prairie School architecture in any Chicago park.

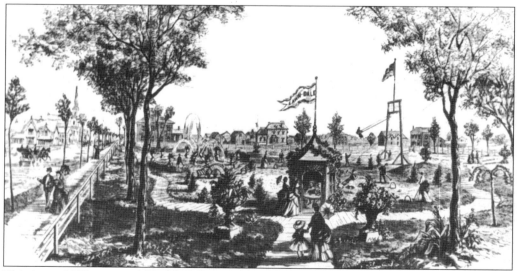

This is an 1880s view of Shedd Park on West 23rd Street, and this photo shows one of the earliest scenes in the park known to exist. Notice the vintage clothing of the women with their bustles and long skirts. A croquet game is being played on the right, and there is a person swinging under the flag in the foreground. Other leisure activities are represented as well, like strolling and riding in the buggy on the far left.

John Graves Shedd (1850–1926) was a local resident of Chicago who went on to become President of Marshall Field & Co. He managed to rise from stock boy to partner to president because of his industry and hard work. He was also a philanthropist who gave generously to various causes in Chicago; Shedd Aquarium is named for him. His original home near the park at 2316 South Millard Avenue is still standing.

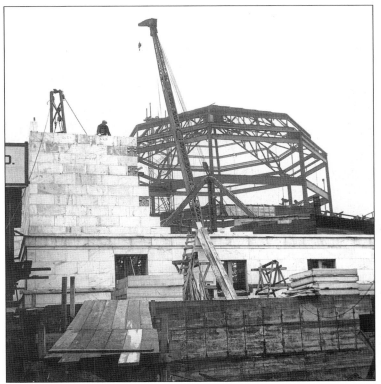

This is a picture of the Shedd Aquarium in the construction process in the late 1920s. The building is the work of the architectural firm of Graham, Anderson, Probst & White who designed it to harmonize with the Field Museum. John Shedd donated $3 million to have the Aquarium constructed, and today it is one of Chicago's most popular attractions.

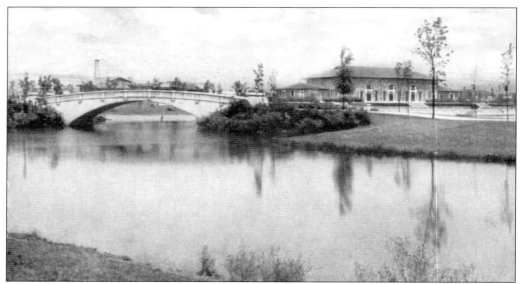

Sherman Park at 1301 West 52nd Street is named after John B. Sherman. The park was planned in 1904 by the Olmsted Brothers, and the Prairie-style fieldhouse was designed by architect Daniel Burnham. The park also achieved the pastoral feeling of much larger parks because of its serene setting and use of water. Within the park is an island surrounded by a lagoon, which is pictured here.

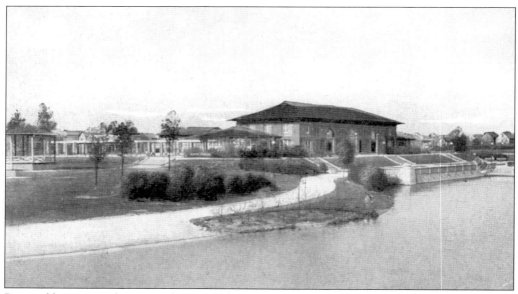

Pictured here is another general view of Sherman Park. Just over 60 acres in size, Sherman Park is built around a picturesque lagoon, which is stocked with fish by the Illinois Department of Conservation. Four different arched bridges span the lagoon. A branch of the Chicago Public Library is located in Sherman Park, which is listed on the National Register of Historic Places.

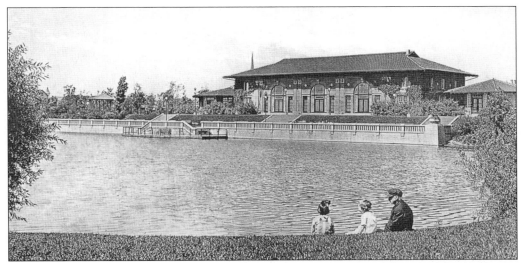

This is a close-up view of the lagoon and fieldhouse in Sherman Park. The boat landing is visible at the bottom of the steps leading to the lagoon. This photograph was taken in the early 1900s, and the park was frequented by neighborhood residents. Note the children in this scene who are sitting on the bank of the lagoon. The terra cotta roof of the fieldhouse is also prominently displayed.

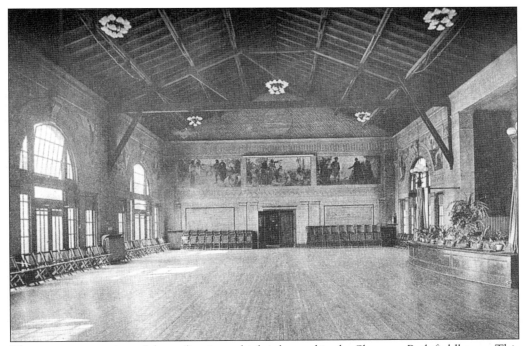

This is an interior view of the auditorium which is located in the Sherman Park fieldhouse. This photograph was taken in the early 1900s. The beauty of the building was reflected in its utilization of wood, glass, light, and color. Note the use of wood in the floors, stage, beamed ceiling, and paneled walls. Light is reflected from the chandeliers, windows, and open spaces, and colorful murals adorn the walls of the auditorium.

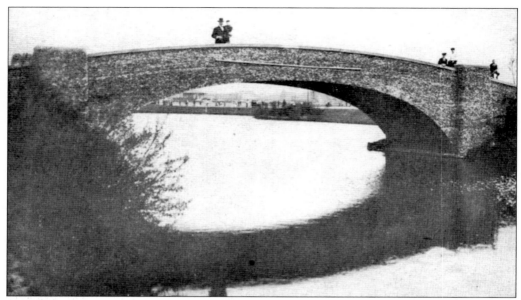

This is a picture of the arched stone bridge that still stands in Sherman Park. Today this bridge looks exactly the same as it did nearly 100 years ago. People continue to gather here and enjoy the view of the picturesque lagoon and surrounding grounds. This is also a popular place to try one's hand at fishing.

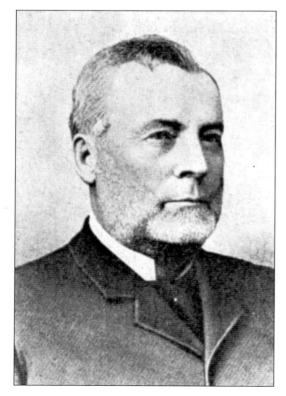

John B. Sherman (1825–1902) was referred to as the "Father of the Stockyards." He accumulated great wealth as the founder of the stockyards and owned a huge mansion on Prairie Avenue. He also served as a South Park Commissioner. Sherman's oldest daughter, Margaret, was married to famous architect Daniel H. Burnham (1846–1912).

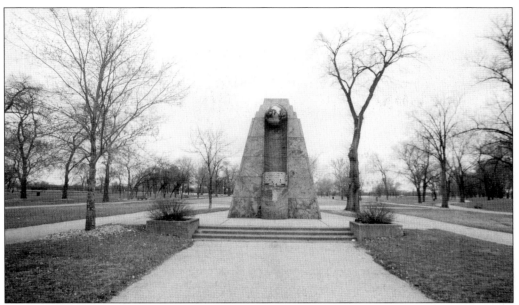

The Darius-Girenas Memorial, by sculptor Raoul Josset, is located in the southeast corner of Marquette Park. It marks the attempted flight of two Chicago pilots from New York to Lithuania in July of 1933. The two pilots, Stephen Darius and Stanley Girenas, were killed when their plane crashed in Germany just 400 miles from their destination. The statue was unveiled in the park in 1934.

Marquette Park at 6734 South Kedzie Avenue is named after the French missionary Jacques Marquette (1637–1675). The park is 323 acres in size, and the land for the park was acquired between 1903 and 1907. The park was designed by Daniel H. Burnham and the Olmsted Brothers, and unofficially opened on July 4, 1906. The park contains a Classical Revival-style fieldhouse and numerous other facilities, including a nine-hole golf course and two lagoons that are popular with fisherman.

McKinley Park, located at 2210 West Pershing Road, is named after William McKinley (1843–1901) the 25th President of the United States. The park, which stands on the former site of the Brighton Stock Yards and Race Track, was officially opened on June 13, 1902. A crowd estimated at over 10,000 people attended the opening day ceremony of the city's first "neighborhood" park. The park was so popular that the size more than doubled over the next two years to accommodate the masses. This is an early 1900s view of the swimming pool in the park.

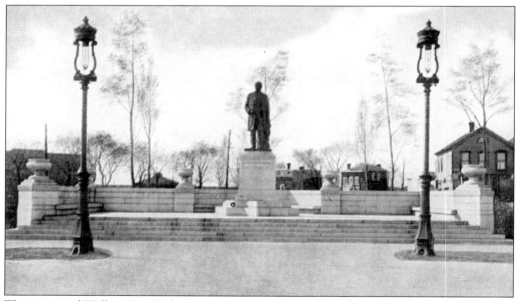

This statue of William McKinley was unveiled in the park on July 4, 1905. The statue is the work of Charles J. Mulligan (1866–1916). This large bronze monument was originally a statue of Columbus, but it received such bad reviews that it was melted down and recast as a statue of McKinley. McKinley was assassinated at the Pan American Exposition in Buffalo, New York, in September of 1901.

80

George Mortimer Pullman (1831–1897) was an industrialist and developer of the railroad sleeping car. He was born in Chautauqua County, New York. As a teenager he was apprenticed to his oldest brother in his cabinet-making business. After some years he left the business to start the development of the first modern sleeping car. In 1880, he established a model city for his employees—the town of Pullman. He is buried in Graceland Cemetery on Chicago's North Side.

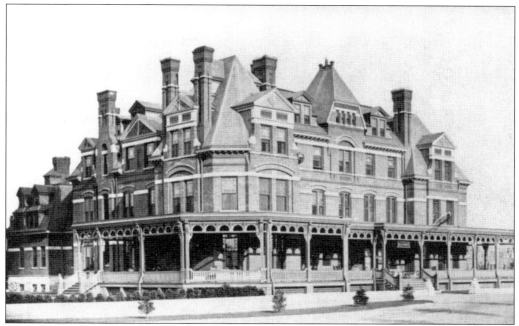

Pullman Park, located at 11101-25 South Cottage Grove Avenue, is named after George Mortimer Pullman. The land was given to the city on January 3, 1910, by the Pullman family under the condition that the land be used as a park, and they also added a condition that no buildings be on the grounds. To this day, there are no structures of any type in Pullman Park. There are, however, small memorial tablets in the park which designate the area as a National Historic Landmark. The park is located next to the Hotel Florence pictured here.

Rainbow Beach Park, located at 2873 East 75th Street and Lake Michigan, is named after the U.S. Army's 42nd Rainbow Division. The Rainbow Division was famed for their heroism in World War I. The land for the park was acquired over a 20-year period between 1908 and 1928, and the park was named on April 22, 1918. This monument, found in the eastern portion of Rainbow Park, was placed in the park on June 18, 1967, to commemorate the 50th anniversary of the Rainbow Division.

Prospect Gardens Park at 10940-11100 South Prospect Avenue is named for the street on which it is found. In fact, it was originally known as Prospect Park. The land for the park was acquired between 1905 and 1910, and the park was renamed on September 29, 1906. It is located in the center of the Ridge Historic District, and many historic mansions face the park. The park is also located across the street from the firehouse and the Morgan Park Christian Church.

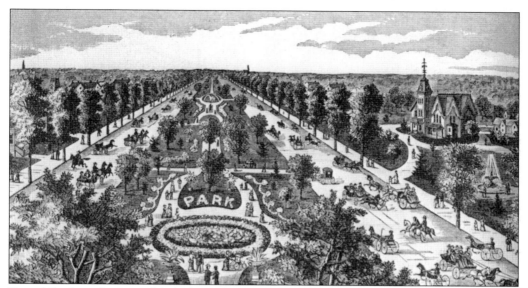

Drexel Boulevard was modeled after a famous avenue in Paris. At one time it was the gem of the boulevard system that linked Chicago's major parks. Two hundred feet wide and nearly 1.5 miles long, the boulevard contained a grassy, broad center strip that was covered with plants, flowers, trees, and shrubs. The strip also contained walking paths, fountains, and benches, giving it a park-like setting.

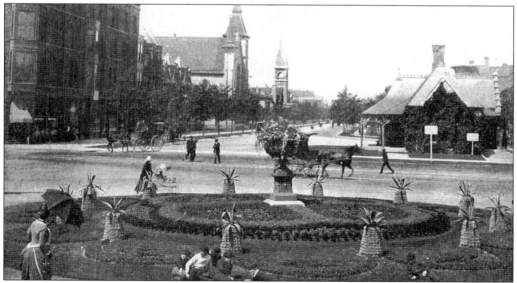

Drexel Boulevard was the creation of Olmsted and Vaux, who designed Chicago's most famous South Side parks. Beautiful homes and mansions lined this boulevard, which led to the entrance of Washington Park. Elegant horse-drawn carriages that transported the Chicago elite were a frequent site on this boulevard. This photo is an 1890s view of Drexel Boulevard where it meets Oakwood Boulevard.

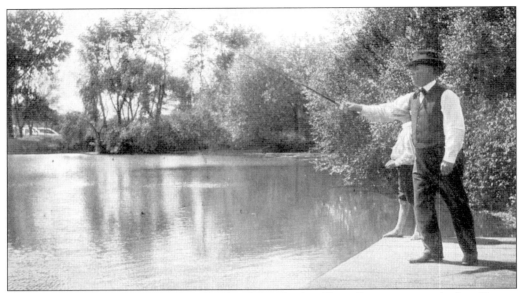

Washington Park, located at 5531 South Martin Luther King Drive, is named after George Washington (1732–1799). The park was established shortly after the Civil War and named in 1880, in honor of our country's first president. The park was designed by Frederick Law Olmsted and Calvert Vaux, and it contained every conceivable amenity that a user of a great park could desire. Pictured here is a man enjoying an afternoon of fishing.

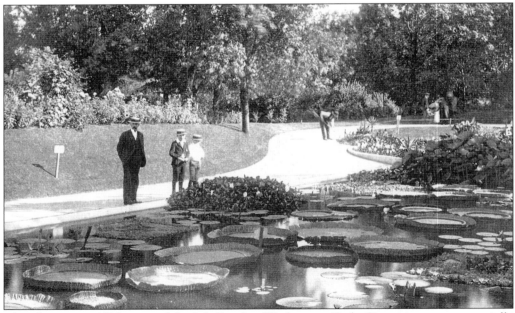

This photo is an 1890s view of the Lily Pond in Washington Park. City visitors were especially attracted to this pond, as many of them had never seen such a lovely sight before. All the paths in the park led to other such picturesque scenes. In short, the transformation of these grounds from a sandy wasteland to beautiful gardens, walks, shady retreats and a lily pond made Washington Park a favorite with many families.

This is an early 1900s view in Washington Park of a tree planted by Ulysses S. Grant. The tree planting ceremony was held on December 6, 1879, and this photograph shows a memorial boulder with a plaque commemorating the event next to the tree. Both the tree and the boulder have since been removed from the park.

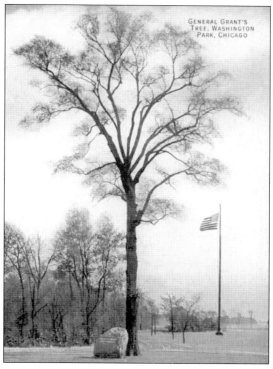

GENERAL GRANT'S TREE, WASHINGTON PARK, CHICAGO

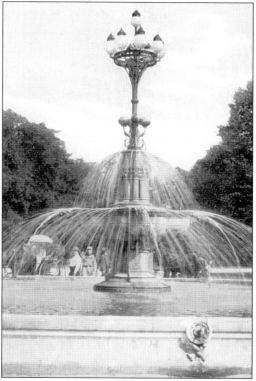

A large drinking fountain for horses marked the Grand Boulevard entrance to Washington Park. In the 1800s and early 1900s, horse-drawn carriages were the primary mode of transportation for visitors to the park. The park contained a giant stable, which held 100 horses and several large fountains like the one pictured here for the use of horses.

This is a view of one of the lagoons found in Washington Park. There were riding stables, cricket grounds, baseball fields, a toboggan slide, archery ranges, a golf course, bicycle paths, row boats, horse shoe pits, greenhouses, a rose garden, a bandstand, and even a small zoo that contained six alligators in the park. Even though many of its former attractions no longer exist, the park is still widely used.

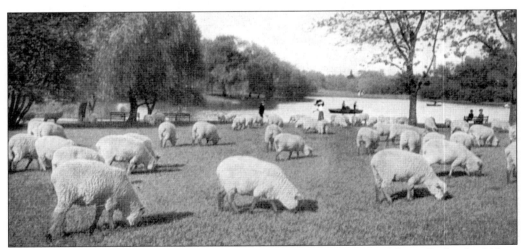

Until about 1920 the lawns in Washington Park were kept trimmed by a flock of nibbling sheep. These sheep were quite fancy Southdown sheep. Numbering 68 in quantity at one point, the expansive meadow with its grazing animals gave the park a sylvan, or pastoral, appearance. This aspect of the park was soon discarded when sheep were no longer allowed.

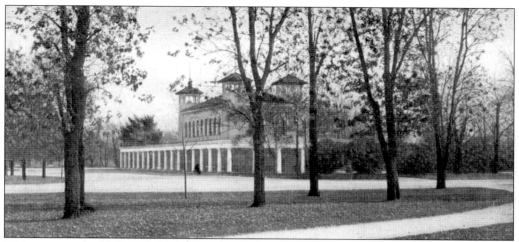

This is an early 1900s view of the refectory in Washington Park. This classically-inspired building was designed in 1891 by architect Daniel Burnham. Winding paths lead to the refectory, which features a ground-level colonnade and four corner lookout towers. The refectory still stands in the park today and recently underwent a complete renovation.

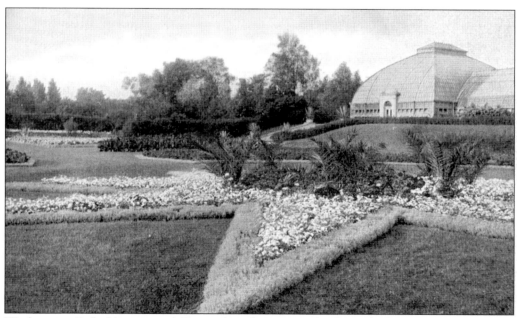

Washington Park, like many of Chicago's early major parks, housed a large conservatory. The conservatory was a huge attraction, but it was also very costly to maintain. In the early 1900s the conservatory was torn down as were the others in Humboldt and Douglas Parks. Chicago residents who wished visit a conservatory were forced to travel to Lincoln or Garfield Park.

Midway Plaisance Park, located from East 59th to East 60th Streets and South Stony Island Avenue to South Cottage Grove Avenue, is so named because it is midway between Jackson and Washington Parks and links the two parks together. The park is really just a very wide boulevard. It is approximately 660 feet across and 1 mile long, with a vast sunken grassy median on the campus of the University of Chicago. The land for the park was acquired between 1869 and 1873, and was designed by Olmsted and Vaux.

The Midway Plaisance has changed very little since this photograph was taken in the early 1900s. It is still a wide open green pasture surrounded by beautiful Gothic buildings, which are part of the University of Chicago, but the streets surrounding the Midway have been paved and a few sculptures have been placed in the park. Besides these minor changes, it looks as though it did 100 years ago.

This is a view of the famous Ferris wheel on the Midway Plaisance during the Columbian Exposition in 1893. Designed by Washington Gale Ferris (1859–1896), it stood over 260 feet in height, weighed over 56 tons, and was made entirely of steel. This engineering marvel was one of the fair's most popular attractions. In addition to the wheel, the Midway housed many other amusements during the fair. As a result, the term "Midway" became synonymous with carnival grounds.

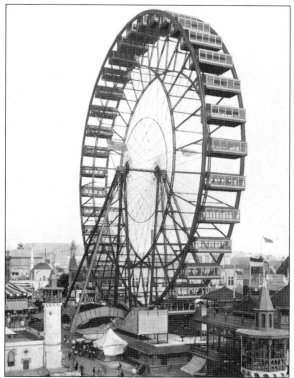

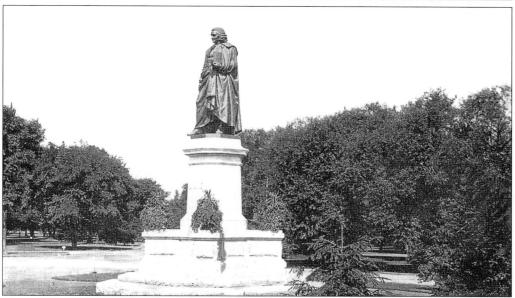

This is a photo of the statue of Swedish botanist Carl von Linne (1707–1778), which stands on the Midway Plaisance and is the work of sculptor Johan Dyfverman (1844-1892). The sculpture is a copy of the original in the Royal Gardens at Stockholm, Sweden. It originally stood in Lincoln Park, but was moved to the Midway and rededicated in a lavish ceremony attended by the King of Sweden in 1976.

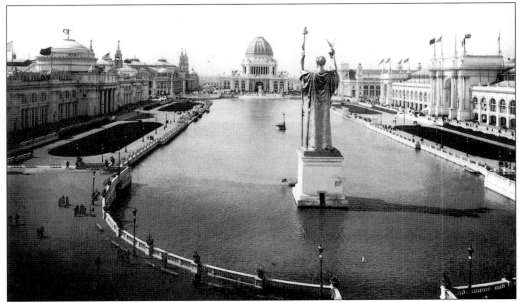

Jackson Park, located at 6401 South Stony Island Avenue, is named after the 7th president of the United States, Andrew Jackson (1767–1845). The park was founded in 1869 and laid out in 1871 by Frederick Law Olmsted and Calvert Vaux, and was officially named Jackson Park on July 11, 1881. It was the site of the Columbian Exposition in 1893. The park contains three major harbors, a yacht club, two beaches, a former U.S. Coast Guard Station, the La Rabida Children's Hospital, the Clarence Darrow Bridge, the recently renovated 63rd Street Beach Pavilion and the Wooded Island.

This is a view in Jackson Park of Wooded Island during the Columbian Exposition in 1893. The Osaka Japanese Garden and huge oak tree, which is believed to predate the arrival of Christopher Columbus in America, can be found on Wooded Island, located between the east and west lagoons of the park. The island is also a very popular site with bird watchers.

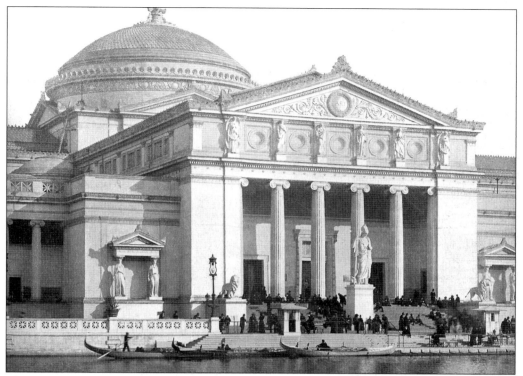

This is a view in Jackson Park of the Palace of Fine Arts during the Columbian Exposition in 1893. Attendees of the Exposition could hire gondolas in the rear of the Palace of Fine Arts to transport them to other buildings throughout the park. Today this wonderful Neo-classical building is known as the Museum of Science and Industry and is the only remaining building from the great 1893 fair.

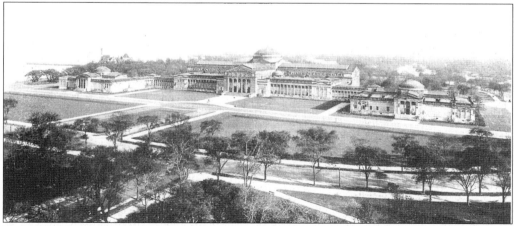

This picture of the Palace of Fine Arts in Jackson Park was taken from the top of the Windemere East Hotel in the 1920s. At the time of this photograph the Palace lay abandoned in a state of disrepair. It was not until 1930, when philanthropist Julius Rosenwald donated $5 million to create the Museum of Science and Industry, that restoration on the building began. Today it is one of the main attractions in Jackson Park.

This is a very early view of the beach at Jackson Park, probably dating back to the 1890s. Note the numerous small horses and buggies that dot the walk. Other people stroll through the area or pause to take in the beautiful lake view. This beach attracted many citizens on a lazy afternoon.

Jackson Park is located between 65th and 67th Streets east of Stony Island and extending to Lake Michigan, and at nearly 543 acres, it is the third largest park in the City of Chicago. The park is listed on the National Register of Historic Places. This is an early picture of the bridge in the park.

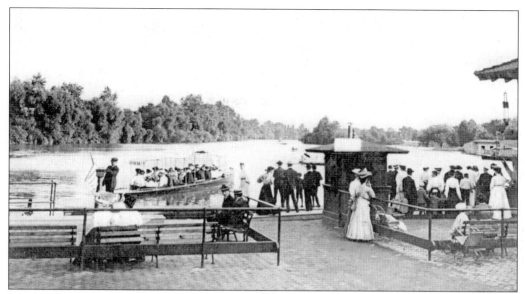

Boating has always played an important role in the history of Jackson Park. During the late 1800s and early 1900s, boating in the park was a very popular activity. Individual boats could be rented, and group tours on somewhat larger boats were also available. Even today the park contains three major harbors and a yacht club. There are also paddle boats available for rent during the summer months, on the Columbian Basin behind the museum.

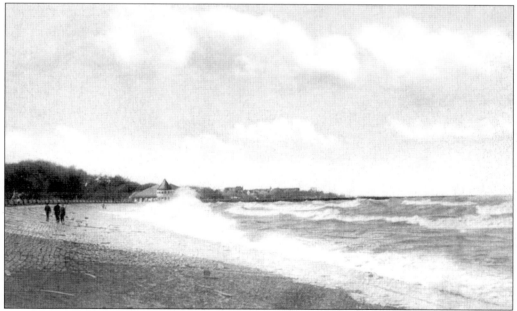

The Jackson Park Beach has also been a popular place for Chicagoans to gather. The old beach house pictured here in the early 1900s no longer stands; however, in 1919 a new beach house was constructed near 63rd Street. This classically-inspired building still exists and just recently underwent a complete renovation, which restored it to its former glory.

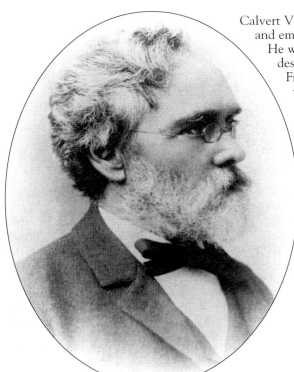

Calvert Vaux (1824–1895) was born in England and emigrated to New York in the early 1850s. He was a renowned architect and landscape designer and planner, and he joined with Frederick Law Olmsted in 1869 to plan what became Midway Plaisance, Jackson, and Washington Parks. These parks are considered to be among the finest examples of Olmsted and Vaux's work. Vaux's book, "Villas and Cottages," has had a lasting impact on architecture along the Eastern seaboard and as far west as California.

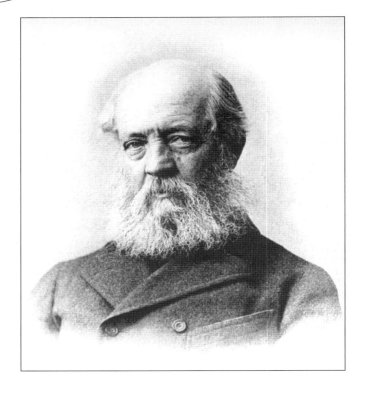

Frederick Law Olmsted (1822–1903), the "Father of American Landscape Architecture," was considered the leading park designer of his time. He undertook to conserve natural settings and make them the focal point of his park designs. In 1869, he and Vaux were hired to design the Midway Plaisance, Jackson, and Washington Parks. Olmsted also designed New York's Central Park and the U.S. Capitol grounds.

Three

PARKS OF THE NORTH SIDE

The first park on the North Side and in Chicago was Dearborn Park, which was established in 1839 at Randolph Street and Michigan Avenue. By 1860, the first move towards establishing Lincoln Park was noted in the records of the city's council proceedings. An issue to be resolved was related to the fact that the south 60 acres of the park contained a cemetery, and the grave sites had to be relocated. By the mid-1860s, an ordinance was passed prohibiting any more burials, and in 1869, the state legislature passed an act creating the Board of Lincoln Park Commissioners. The park, however, was not officially opened until 1874.

As the park system expanded, many other parks were created on the North Side. Some of the parks are pictured here, including Buffalo, Eugene Field, Gompers, Horner, Independence, Indian Boundary, Loyola, Monument, Peterson, Portage, Ravenswood Manor, Senn, Warren, and Wicker. These parks range in size from less than .1 acres (Buffalo) to over 1200 acres in size (Lincoln). These parks offer a wide range of activities and facilities from small playgrounds (Ravenswood Manor) and golf courses (Warren) to scenic sites such as duck ponds (Indian Boundary) and conservatories (Lincoln). Fieldhouses, beaches, and lagoons can also be found in some of the parks.

Many monuments and statues can be found in these North Side parks; however, Lincoln Park has the richest collection, including monuments to honor the likes of Lincoln, Grant, Schiller, Goethe, Benjamin Franklin, Shakespeare, and Hans Christian Anderson. Many other parks including Senn, Horner, Indian Boundary, and Monument Park contain their share of sculpture as well. Examples of these art forms are depicted in some of the scenes that follow.

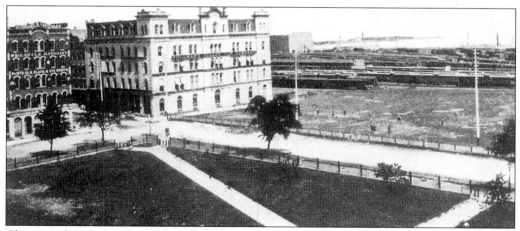

Chicago's first park was Dearborn Park, established in 1839. This 1.08 acre parcel of land had formerly been a part of the old Fort Dearborn military post, and it was named in honor of General Henry Dearborn. The park stood until 1892 when ground was broken on the site for the construction of the Chicago Public Library, and the building now serves as the Chicago Cultural Center.

Famous social reformer Jane Addams (1860–1935) was a settlement worker and author. She was also the founder and director of Hull House, Chicago's first settlement house. Addams was awarded the Nobel Peace Prize in 1931. The Jane Addams Hull House Association still exists today and continues to provide assistance to nearly 250,000 people annually.

This is an early 1920s photograph of Navy Pier Park at 550 East Grand Avenue. The park was given its name because of its location near the entrance to Navy Pier. Today the park is known as Jane Addams Memorial Park. A monument to Addams designed by Louise Bourgeois was unveiled in the park on August 16, 1996, the same day the park was renamed in her honor.

Washington Square Park, located at 901 North Clark Street, is the oldest existing park in the City of Chicago. The land where the park now stands was originally a cow path with a well where farmers would stop to water their cattle. Named in honor of the first President of the United States, the land for the park was donated to the city on September 9, 1842, by a group of land speculators known as the American Land Company. The park is currently listed in the National Register of Historic Places.

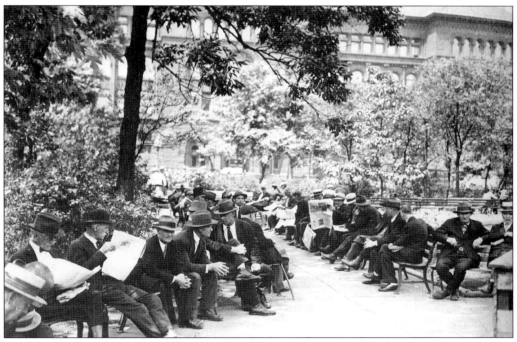

Washington Square Park is also known as "Bughouse Square," because it was the site of rousing nightly speeches and mental hospitals which at that time were often referred to as "bughouses." Once a year the Newberry Library, which is located directly across the street from the park, sponsors a festival that recreates the various debates and speeches by soap box orators that once took place in the park. There is also a memorial tablet on the west side of the park that designates the park as "Chicago's Premier Free Speech Forum."

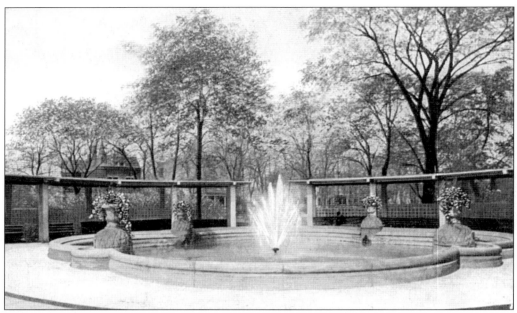

Wicker Park at 1425 North Damen Avenue is named after Joel H. and Charles G. Wicker. In 1868 these brothers donated a triangular parcel of land in the middle of their subdivision to the city to be used as a park, because they wanted to enhance their real estate investments. This park still stands today and is one of the oldest in the City of Chicago. This is an early 1900s view of the fountain and the shelter that surrounded it.

Wicker Park has been altered over the years. At one time this 4-acre park contained a small lake with beautiful bridges. The lake has been filled in, and the bridges no longer exist. However, the park is still surrounded by elegant mansions and classic graystone residences. The original fountain from the 1880s remains in the park, but it has been converted into a spray pool. The shelter that once stood beside the fountain has also been removed.

Kelvyn Park at 4438 West Wrightwood Avenue is named after the subdivision in which it is located. The subdivision was named by Scottish settlers in honor of the eighth Lord of Kelvyn. The land for the park was acquired between 1914 and 1916, and the park was named on July 20, 1914. The park's fieldhouse was designed by architect Walter Ahlschlager in 1928.

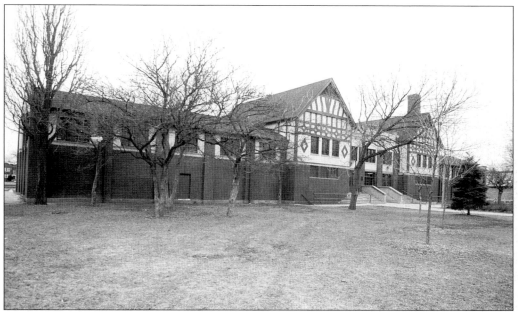

Kosciuszko Park, located at 2732 North Avers Avenue, is named after Thaddeus Kosciuszko (1746–1817), a United States and Polish war hero. The land for the park was acquired in 1914, and there was a large and formal dedication ceremony on July 4, 1916. The park was officially named in honor of Kosciuszko on June 14, 1922. An impressive statue of Kosciuszko sitting astride a horse stands in Burnham Park.

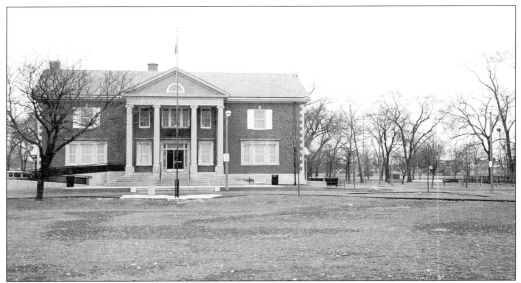

Shabbona Park at 6935 West Addison Street is named in honor of Shabbona (1775–1859), a heroic Indian Chief of the Ottawa tribe who lived in the area. The land that the park sits on was originally Indian land. Shabbona continued to live in the area even after white settlers came and took over the land. His good friend was Indian Chief, Billy Caldwell (1780–1841), and the two are credited with saving the lives of many prisoners captured during the Fort Dearborn Massacre in 1812. The land for the park was purchased in 1926 and 1927, and the Classical Revival-style fieldhouse was designed by Albert Schwartz.

Riis Park, located at 6100 West Fullerton Avenue, is named after Danish-American journalist and social reformer Jacob August Riis (1849-1914). He is best known for his association with the public park and playground movement. His book, How the Other Half Lives, inspired social reformers in both New York and Chicago to create more playgrounds and parks. The land for Riis Park was acquired in 1916; the park was named on October 19, 1920, and officially opened on July 4, 1921. The park's Colonial Revival-style fieldhouse was designed by architect Walter Ahlschlager in 1929.

Blackhawk Park at 2318 North Lavergne Avenue is not named after the Chicago Blackhawks Hockey Club, but rather after the old 86th Division of the National Army from Illinois, known as the Blackhawk Division A.E.F. The Division consisted of troops from Chicago and other parts of Illinois. They chose the park's name in memory of the Sauk Indian Chief Black Hawk (1767–1838), who lived in the area briefly. The land for the park was acquired between 1916 and 1922, and the fieldhouse was designed by architect Albert Schwartz in 1926.

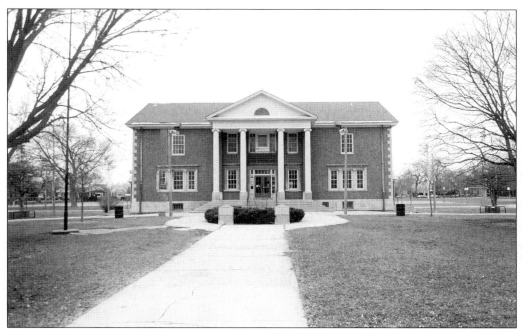

Chopin Park, which is over 8 acres in size, is located at 3420 North Long Avenue. It is named after the great piano composer and musician Frederic Chopin (1810–1849), who established the piano as a solo instrument—free from choral or orchestral influence. The park's Classical Revival-style fieldhouse was designed by architect Albert Schwartz in 1928.

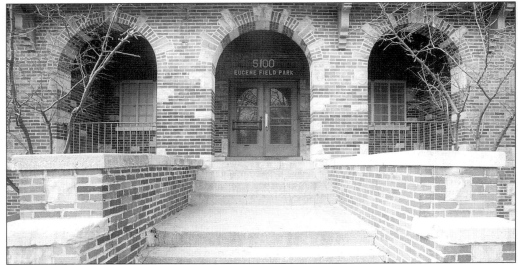

Eugene Field Park at 5100 North Ridgeway Avenue is named after the journalist and poet, Eugene Field (1850–1895). He wrote a column for the *Chicago Daily News*, but it is his poetry for which he is remembered. The park was originally known as Center Park, but it was renamed in honor of Field on November 15, 1926, and the opening ceremony was held on October 22, 1928. The land for the park was purchased over a period of ten years from 1923 to 1933. The Tudor Revival-style fieldhouse pictured here was designed in 1928 by architect Clarence Hatzfeld (1873–1943).

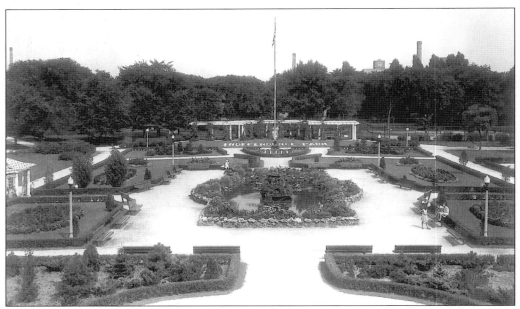

Independence Park, located at 3945 North Springfield Avenue, is so named because in the early years of the park, great celebrations were held there every 4th of July to celebrate America's Declaration of Independence. The land for the park was acquired between 1911 and 1930, and the Prairie-style fieldhouse was designed in 1911 by architect Clarence Hatzfeld (1873–1943). A branch of the Chicago Public Library was located inside the fieldhouse from 1914 until 1995. Independence Park is bounded by Irving Park Road, Hamlin, Byron, and Springfield Avenues.

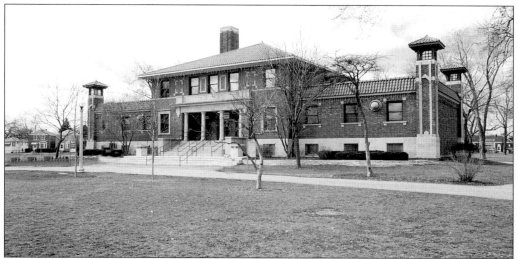

Portage Park at 4100 North Long Avenue is named after the old portage trail that ran through the park. The Pottawattomie Indians used the trail to transport their goods between the Des Plaines and Chicago Rivers. Part of the park was a pond that was used for boating. The land for the park was acquired on January 3, 1913, and the Prairie-style fieldhouse was designed in 1922 by architect Clarence Hatzfeld (1873–1943). In 1958, the Pan American games were held at the park.

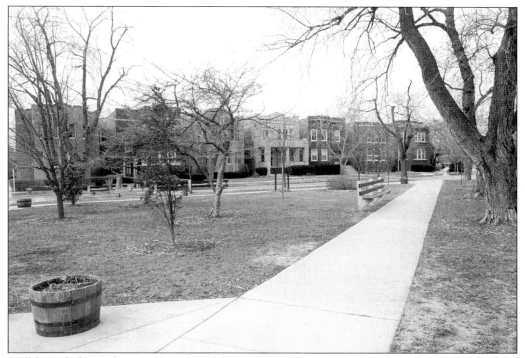

Buffalo Park, located at 4501 North California Avenue, is named after a huge fountain with three large buffalo heads that was placed in the park in 1917. It is a small triangular park that is bounded by Manor, Sunnyside, and California Avenues. The land for the park was purchased in 1915. The fountain no longer remains in the park, but it is still surrounded by beautiful older homes.

Gompers Park at 4222 West Foster Avenue is named after American labor leader Samuel Gompers (1850–1924). The land for the park was acquired between 1927 and 1932, and was originally known as Matson Park in honor of Samuel Matson, a superintendent of the Albany Park District. The park's Tudor Revival-style fieldhouse was designed in 1932 by architect Clarence Hatzfield.

Brands Park at 3259 North Elston Avenue is named after Virgil M. Brand, president of the Brands Brewing Company at 2530 North Elston. The company was a very large brewery producing about 200,000 barrels of beer annually. Brand also owned a fair amount of land in the area around his brewery, and one such parcel near Belmont and Elston Avenues proved to be perfect for this park. The land was acquired from Brand in 1927. This is a view of the brewery around 1900.

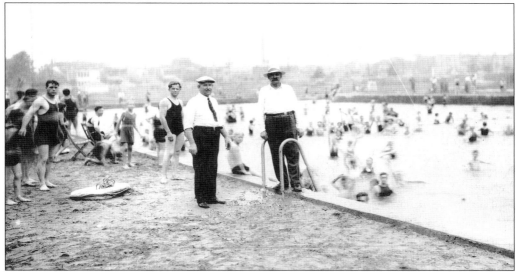

California Park at 3843 North California Avenue is so named because the western portion of the park is located on California. The land for the park was purchased between 1917 and 1931. The McFetridge Sports Center is located in the park. William L. McFetridge (1894–1969) was head of the Chicago Park District and leader of the Building Service Employees International Union for 20 years. This is an early view of the swimming pool in the park.

Bell Park, located at 3020 North Oak Park Avenue, is named after Major General George Bell Jr. (1859–1926), a war hero in the Spanish-American War, the Philippine Insurrection, and the First World War. When he died in October of 1926, his body lay in state at his residence in the Belden-Stratford Hotel at 2300 North Lincoln Park West. Bell is buried at Rosehill Cemetery in Chicago next to his wife Minnie H. Ransom Bell (1858–1930). The land for the park was acquired in 1927 and 1928.

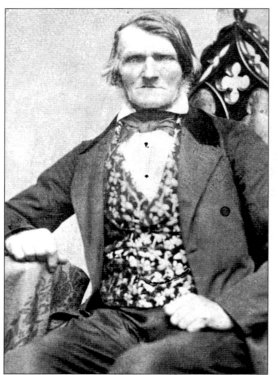

Conrad Sulzer (1807–1873), pictured here, purchased 100 acres of land and built a home on the corner of what is now Clark Street and Montrose Avenue (Montrose Avenue was actually Sulzer Road many years ago). The history of Ravenswood Manor can be traced back to 1836 when Sulzer, a Swiss immigrant, settled there with his family. The area became known as Ravenswood Manor after the Ravenswood Lumber Company set up shop on part of the old Sulzer family farm in 1868.

Ravenswood Manor Park at 4604-46 North Manor Avenue is so named because it is located in the North Side neighborhood of Ravenswood Manor. The park has been a fixture in the community since it was established on June 22, 1915. Less than 1 acre in size, this small triangular-shaped park features old fashioned street lights, a Japanese-style pergola, and a playground for children.

Henry Horner (1878–1940) was born and educated in Chicago and attended public schools in the city. He also went to the University of Chicago and Kent Law School. He was admitted to the Illinois Bar in 1899, became a judge, and served as Governor of Illinois from 1933 until 1940. A recognized authority on Abraham Lincoln, he gathered a priceless collection of manuscripts and documents about him.

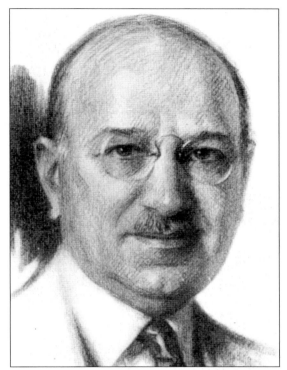

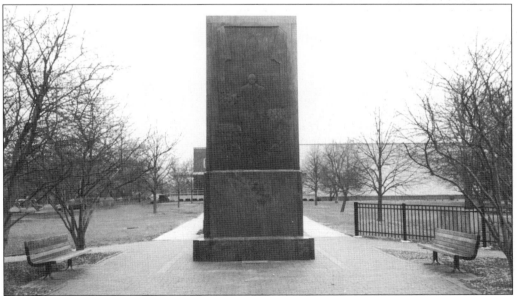

Horner Park, located at 2741 West Montrose Avenue, was named in honor of Henry Horner. The land for the park was acquired in 1946. It was originally a clay pit and later a city dump, and it took several years to fill in the clay pits and clean up the area. In the park there is a large red granite monument by sculptor John D. Brcin honoring Horner. The monument originally stood in Grant Park but was moved to the present site in November of 1956, and was dedicated on December 5, 1956. The Horner Park fieldhouse was also dedicated in December of 1956.

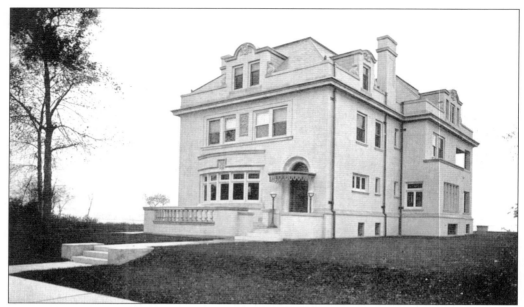

Berger Park at 6205-47 North Sheridan Road is named after Albert E. Berger (1900–1950). He was a realtor who formed the Albert E. Berger Company in the 1920s. The park is located between high-rise buildings overlooking Lake Michigan, and contains two historic lakefront mansions. This is a view in 1910 of the Samuel H. Gunder mansion, which is now used as the North Lakeside Cultural Center and is a popular attraction with park visitors.

Loyola Park, located at 1230 West Greenleaf Avenue, was originally called North Shore Park, is named for the founder of the Jesuits, St. Ignatius of Loyola (1491–1556). The land was acquired for the park between 1909 and 1917, and was officially named North Shore Park on December 21, 1909. The name of the park was changed on December 7, 1937, because residents in the area felt the name reflected a location in the suburbs. The fieldhouse, which cost $550,000 to build, was dedicated in September of 1951.

Mozart Park at 2036 North Avers Avenue is named after Austrian composer Wolfgang Amadeus Mozart (1756–1791). A remarkable prodigy, he was taught to play several musical instruments by his father, and began composing music before he was five years of age. The 4.5 acres of land for the park were purchased in 1914, and are located in the 31st ward.

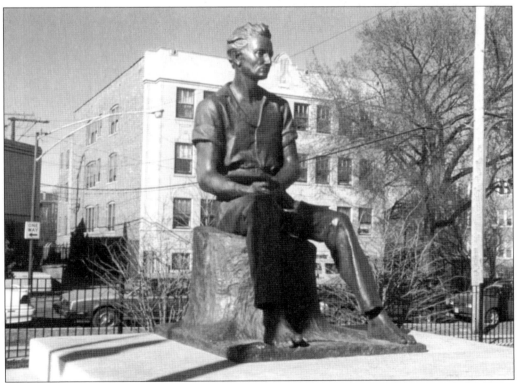

Senn Park, located at 5887 North Ridge Avenue, is named after surgeon Nicholas Senn (1844–1908). A hotel and tavern known as the Seven Mile Inn, which was built in 1848, once stood on the site. It was named the Seven Mile Inn, because it was located seven miles from city hall in downtown Chicago. Abraham Lincoln attended a political caucus and stayed overnight at the inn during his 1860 campaign for president, and a statue of him has been placed in the park to commemorate the occasion. The statue entitled "Young Lincoln" by sculptor Charles Keck (1875–1951) is 13 feet high and weighs 3,000 pounds.

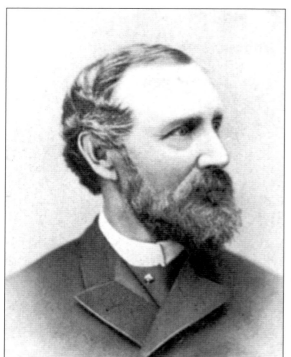

Peher Samuel Peterson (1830–1903) was born in Sweden and studied horticulture as a young man. He came to the United States in 1851, and settled in Chicago within a few years. Shortly thereafter, he established a large nursery in the area where Peterson Park now stands. His trees and shrubs were planted all over the city, especially after the Chicago Fire in 1871, which destroyed much of the city's foliage. He also planted all the trees for the Columbian Exposition in 1893.

Peterson Park at 3200 West Ardmore Avenue is named after Peher Samuel Peterson. This is a rare photograph of the Peterson home in the early 1890s. The home was part of an estate and nursery that stretched over 400 acres on Chicago's North Side. Peterson died in this home at Lincoln and Peterson Avenues in 1903. Shortly after his death, his family donated 160 acres of his land to the city, which was used for the Municipal Tuberculosis Sanitarium. In 1977, the land was converted into a park and named in Peterson's honor.

Edison Park, located at 6755 North Northwest Highway, is named for the community of Edison, which, in turn, is named after American inventor Thomas Alva Edison (1847–1931). The park was originally known as Ebinger Park in honor of Christian Ebinger, the first settler in Edison Park. The Edison Park School once operated on the site. It has since closed, but the school building, which was constructed in 1907, now serves as the park's fieldhouse. The park was renamed on March 23, 1937.

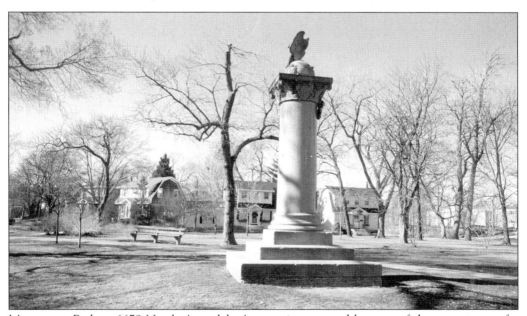

Monument Park at 6679 North Avondale Avenue is so named because of the monument of a pillar with an eagle atop that is located in the park. It was taken from the old Cook County Courthouse and relocated to the park in 1918. The monument was erected by the citizens of Edison Park in honor of those who served in the United States Armed Forces during the First World War. Even to this day, the local branch of the American Legion continues to place wreaths on the monument as a tribute to the veterans. The land for the park was acquired in 1913.

Indian Boundary Park at 2500 West Lunt Avenue is named in honor of the Treaty of 1816 that was signed with the Pottawatomie Indians who once inhabited the area. The treaty established a boundary line with the Indians, and the land for the park was acquired between 1915 and 1922. The park was named on October 23, 1916, to celebrate the centennial anniversary of the signing of the treaty, and it was officially opened in 1922.

This is a picture of the Tudor Revival-style fieldhouse that is found in Indian Boundary Park. It was designed in 1929 by architect Clarence Hatzfeld (1873–1943). The auditorium inside the fieldhouse features a wooden beamed ceiling and chandeliers decorated with replicas of Indian artifacts. The park contains a small zoo, a duck pond, an elaborate playground, and a fieldhouse.

There are also several monuments in Indian Boundary Park. The largest and most well-known of these monuments is a memorial to our country's founding father, George Washington (1732–1799). This monument was originally a keystone taken from the arch of the Washington Street entrance to the old city hall, which stood from 1877 until it was torn down between 1906 and 1908. The Washington monument was unveiled in the park on July 4, 1927.

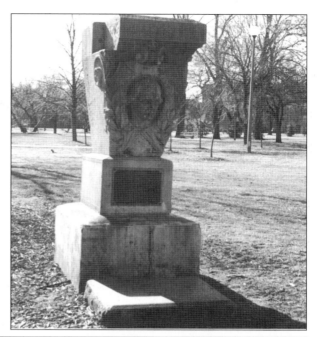

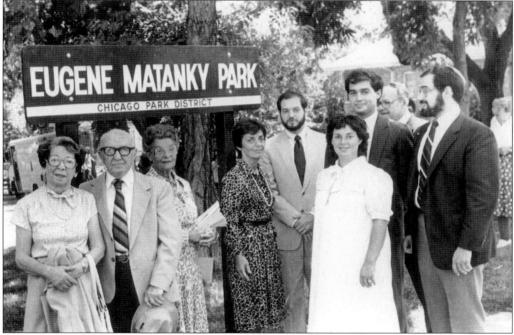

Matanky Park, located at 6925-49 North Ridge Avenue, is named after Eugene Matanky (1922–1982), one of the founders of the Jewish Community Council of West Rogers Park, who was very involved in community affairs. When the land for the park was first acquired between 1912 and 1924, it was known as Morse Park because of its location on Morse and Ridge Avenues. The park was renamed in honor of Matanky on January 10, 1984. This is a photograph of members of the Matanky family at the formal rededication ceremony held in July of 1984.

Christian Peter Paschen (1884–1954) was born in Chicago and attended local public schools. He owned a large company that cleaned and tuckpointed buildings, and was the Commissioner of Buildings under Chicago Mayor William H. Thompson from 1927 until 1931. He was also involved in various community groups. Paschen resided at 5909 North Kenmore Avenue. He was one of the city's most popular public men, and he devoted time to helping underprivileged youngsters.

Paschen Park at 1932 West Lunt Avenue is named after Christian Peter Paschen (1884–1954). The park was established on February 4, 1929, and the original fieldhouse, pictured here on the east side of the park, is still standing. Less than 1 acre in size, this little park is located in the Rogers Park neighborhood on the city's North Side. It is a fitting tribute that a park is named after Paschen, because he was so well known for his work on behalf of children.

Kelly Park at 3800-4000 North Seminary Avenue is named after John H. Kelly (1923–1944), one of ten children who grew up in the 1000 block of Irving Park Road. He attended St. Michael's Central High School, and was a private in the United States Army during the Second World War. While serving in France, he was killed in action on December 19, 1944 at the age of 21.

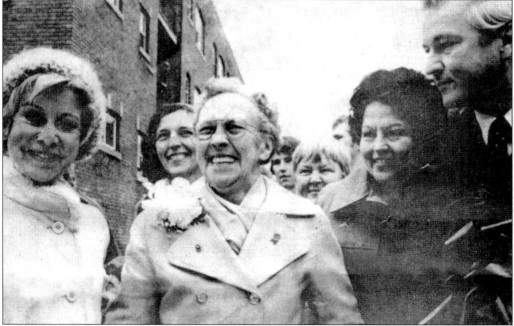

This is a photograph of the dedication of Kelly Park, which took place on October 25, 1980. The ceremony was attended by members of the Kelly family, local residents, politicians, military officials, the 81st Army Band, the Ft. Sheridan Color Guard, and various other groups. Speeches were given by Army General Michael Healy and Chicago Mayor Jane Byrne. Following the ceremony, a reception was hosted by the mother of the fallen hero in the home the family had owned since 1919. Even today, members of the Kelly family live in the same house.

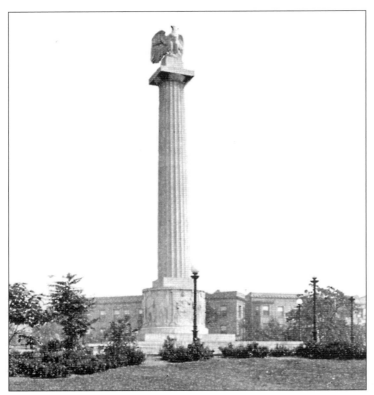

Logan Square Park, located at the intersection of Logan and Kedzie Boulevards, is named after Civil War General John A. Logan. This small circular park was designed in 1870 by architect William Le Baron Jenney. The Illinois Centennial Monument, which was erected in 1918 to commemorate the 100th anniversary of the state of Illinois, stands in the heart of Logan Square. The monument is the work of architect Henry Bacon (1866–1924) and sculptor Evelyn Beatrice Longman (1874–1954).

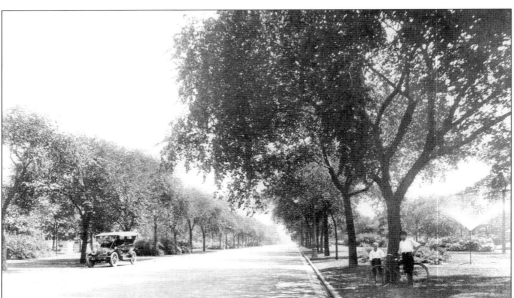

Logan Boulevard is part of the original park and boulevard system, providing a link which connects Lincoln Park to Humboldt Park. The boulevard contains a broad center strip that is covered with grass and trees and is surrounded on both sides by elegant brown and graystone homes. This is a 1915 view looking east from Milwaukee Avenue.

This is an 1863 plat of Cemetery Park that was to become Lincoln Park. The south end of the park from North Avenue to Wisconsin Street was originally used as a cemetery, and the northern portion of the land up to Asylum Place was reserved for park purposes. This is one of the earliest maps of Lincoln Park that is known to exist.

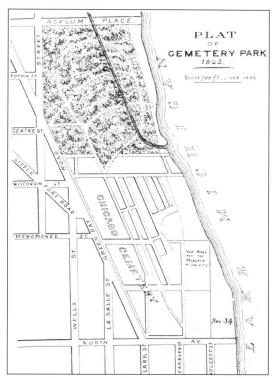

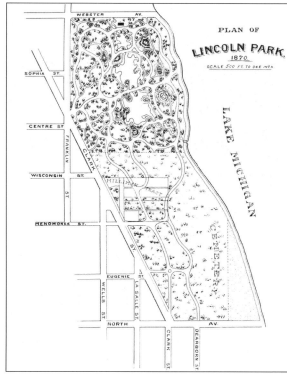

This is a map of Lincoln Park sketched in 1870 by park engineer J.H. Lindrooth. At the time of this drawing, the park was beginning to take shape. The northern portion of the park between Wisconsin Street and Webster Avenue was improved with a series of carriage drives and walkways, and a large number of trees and shrubs were also planted throughout the park.

By 1899 Lincoln Park had become the largest park in Chicago, offering a wide range of facilities and activities, as illustrated by this 1899 map. Listed at the bottom, for example, is an explanatory index to the parks' features—note the rich sculpture collection, zoo, fountains, conservatory, ponds, tennis courts, baseball grounds, and bandstands.

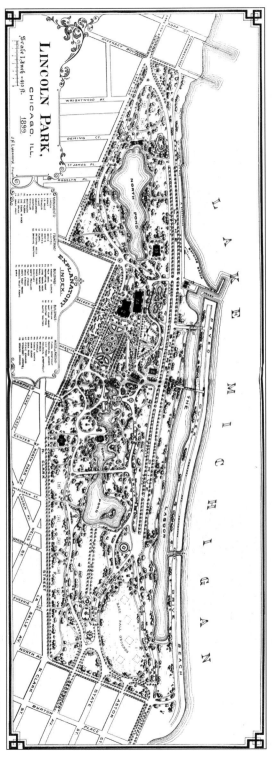

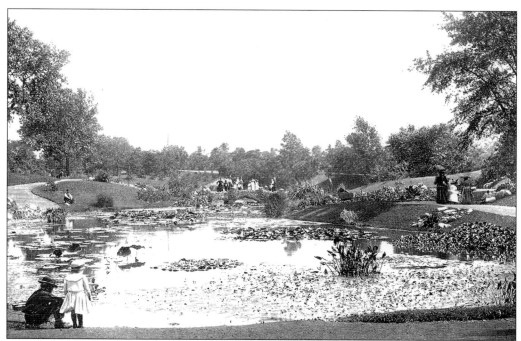

This is an early 1890s view of one of the lily ponds in Lincoln Park. The first pond was constructed in the park in 1889, and it was so popular that two others soon followed. The lily ponds were favorite gathering places for early Chicago residents. Although the ponds no longer exist, Lincoln Park is still considered to be one of the city's most picturesque parks, and it is unquestionably the city's largest and most popular park.

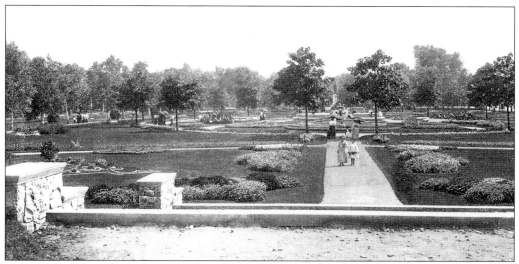

This is a late 1890s view looking south from the Lincoln Park conservatory towards the formal French garden, which was created in the late 1880s. The conservatory and garden had been designed to attract residents who wished to enjoy the beauty of nature. Though both have been altered to some degree, they still exist in the park today. In this photo, park visitors are seen leisurely strolling through the garden.

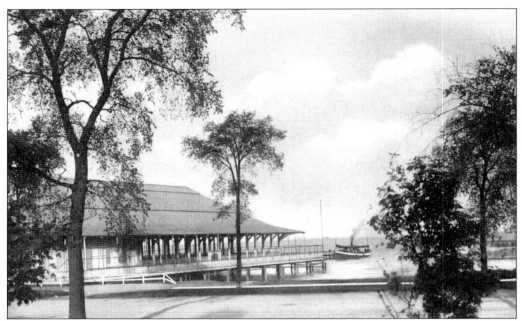

This is a view of the Children's Sanitarium which once existed on Lincoln Park's lakefront before 1898. As early as 1878, the use of the North Avenue pier was granted to the Floating Hospital Association, and a pavilion was erected for the benefit of sick babies and their mothers brought there from the crowded city in a steamboat chartered by the association. Notice the steamboat to the right in the background.

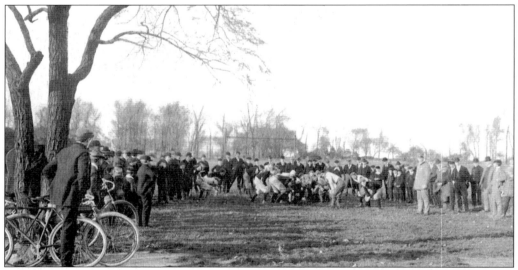

This is an 1890s view of a football game on the grounds of Lincoln Park. Park commissioners had made an early effort to encourage the exercise of sports and games in the park, and as a result, diamonds for baseball and football as well as courts for tennis were marked out for the free use of the public. When the practice of setting aside part of the park for such use started, opponents complained that since Lincoln was a public park, it was illegal to have such special privileges. The right to encourage sports and games was not contested for long.

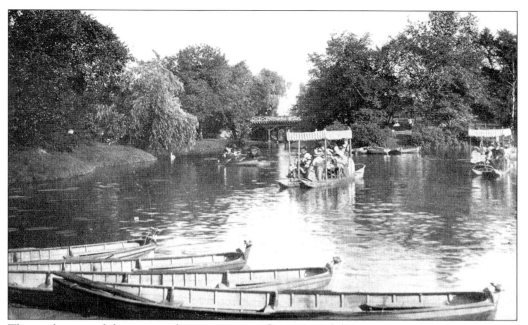

This early turn of the century boating scene reflects one of the many uses for which Lincoln Park has been known and remembered. In addition to its miles of drives, walks, and bridges, there were originally 20 acres of lake surface. At one time the water was dotted with row boats, as a favorite pursuit of many city dwellers was utilizing the park for recreation.

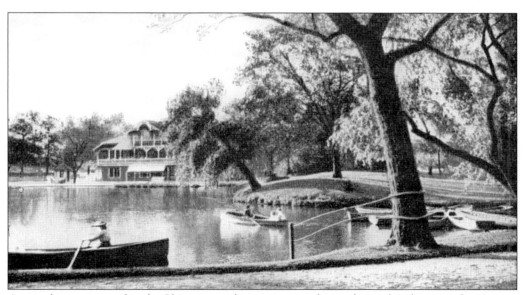

A popular pastime of early Chicago residents was spending a leisurely afternoon boating in Lincoln Park. Even today, boats can be rented in the park during the summer months for a small fee.

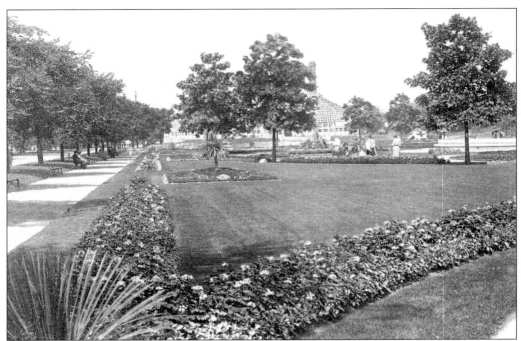

The Lincoln Park conservatory was designed by architect Joseph Lyman Silsbee in 1894. It houses hundreds of different types of plants, trees, and shrubs. The conservatory overlooks two gardens that were created in the 1880s—the informal English-style perennial garden on the west and the formal French garden on the south. Today the conservatory is still popular with visitors as they gather at its four annual shows.

The Lincoln Park high bridge, also known as suicide bridge, was a popular park attraction for many years. Construction on the bridge began in 1893 and was completed in 1894. At one time the bridge enabled park patrons to cross over from the beach drive to the inner drive, and it also served as an observation deck. The bridge no longer remains in the park.

The statue of Robert Cavelier de LaSalle (1643–1687) was designed by Jacques de la Laing. LaSalle has long flowing hair and is armed with sword and pistol, while his legs are encased in high leather leggings. The statue was cast in Belgium and shipped to Chicago where it was unveiled in 1889. It is found in Lincoln Park, on the east side of Clark Street, north of the juncture with LaSalle Street.

The statue of Grant (1822–1885) is located in Lincoln Park. The figure and horse measure 18 feet, 3 inches from the bottom of the plinth to the top of the hat. The face of the figure shows a calm Grant in repose atop a Kentucky thoroughbred that he rode during the Civil War. The statue was designed by Louis T. Rebisso and was dedicated in 1891. The monument was provided for by voluntary contributions to a fund that was started shortly after Grant's death in 1885.

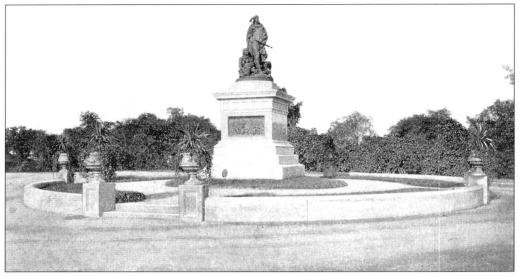

"The Alarm" is the earliest work in Chicago to portray American Indians. It depicts a brave and his seated squaw with their papoose and dog, and they all seem to be alert to some pending danger. The statue was designed by John J. Boyle in 1884. The sculptor's donor was Martin Ryerson, who spent several years trading with Indians in Michigan; thus, the inscription on the base of the statue reads: "To the Ottawa Nation of Indians, my early friends." It is located in Lincoln Park east of Lake Shore Drive, approximately in line with West Wellington Avenue.

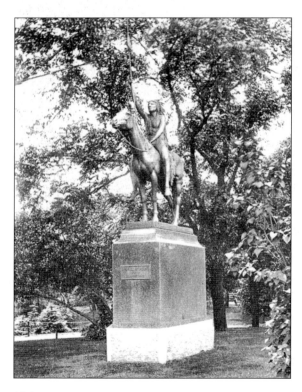

Entitled "A Signal of Peace," this statue represents a Sioux Chief on horseback. His right hand is holding a spear pointed upward in a gesture of peace. The work was designed by Cyrus Dallin in 1890 and installed in 1894 north of the entrance to Diversey Harbor, and east of Lake Shore Drive in Lincoln Park. It was donated by Lambert Tree who had seen the work on exhibit in 1893 at the World's Columbian Exposition.

Sculptor John Gelert designed this realistic bronze statue of Hans Christian Anderson (1805–1875). Unveiled in Lincoln Park in 1896, Anderson is seated upon a tree stump. The fingers of his left hand are holding his place in a book that rests on his right knee. Behind the figure is a swan, representing the "Ugly Duckling," one of Anderson's best loved stories.

This monument of Shakespeare (1564–1616) was designed by William Ordway Partridge. The statue was first seen at the Columbian Exposition, although it was always intended to be placed in Lincoln Park, where it finally rested in 1894. At the unveiling there were lines of carriages along the roadways, and a mass of people for several hundred feet around the pedestal. The work was cast in bronze in Paris and shipped to Chicago. Partridge studied 137 portraits of Shakespeare before he undertook the project.

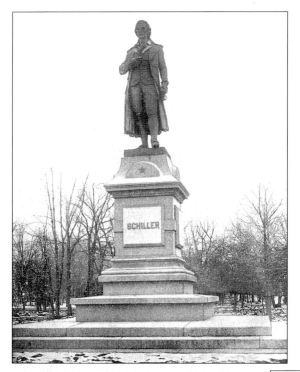

The bronze figure of the German playwright and poet Schiller (1759–1805) is found in Lincoln Park at the southern end of the Conservatory Garden, east of Stockton Drive at Webster Avenue. It was designed by Ernst Bildhauer Rau and was dedicated on May 8, 1886, before 8,000 people. The sculpture is a copy of another to be found in a garden in Marbach where Schiller was born.

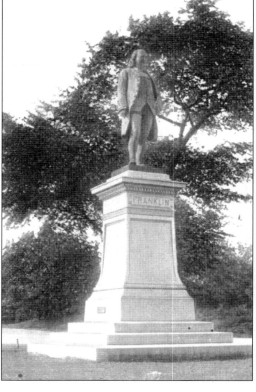

This is an early 1900s view in Lincoln Park of the Franklin Monument, which is located in the southern portion of the park. This statue of Benjamin Franklin (1706–1790) was unveiled in the park on June 6,1896 by one of his descendants. The statue is the work of sculptor Richard Henry Park (1832–1902).

This is a view in 1915 of the Goethe Monument in Lincoln Park. The statue is located near the southeast corner of Diversey Avenue and Sheridan Road. The 25-foot monument was unveiled in 1913 to honor the German poet Johann Wolfgang von Goethe (1749–1832), and is the work of sculptor Herman Hahn (1868–1944).

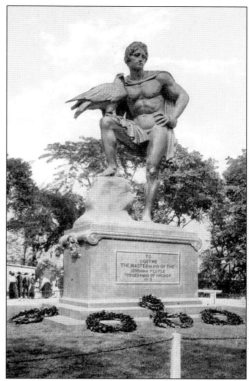

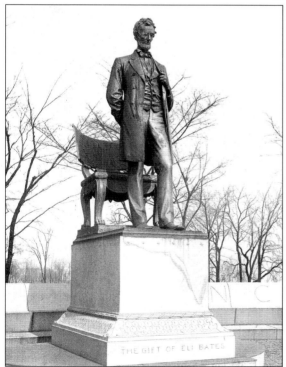

This statue of the great emancipator which stands in Lincoln Park, is the work of sculptor Augustus St. Gaudens. It was the posthumous gift of Eli Bates, who left $40,000 in his will for the creation of such a memorial. The colossal 11–foot bronze statue stands on a granite pedestal in a posture of meditation. This sculpture, which is located behind the Chicago Historical Society, was unveiled on October 23, 1887.

This is a 1902 map of the parks that existed in Chicago.